IMAGES
of America

AROUND
PALM HARBOR

To Richard
Hope you enjoy our early
history
Winona Regile Jones

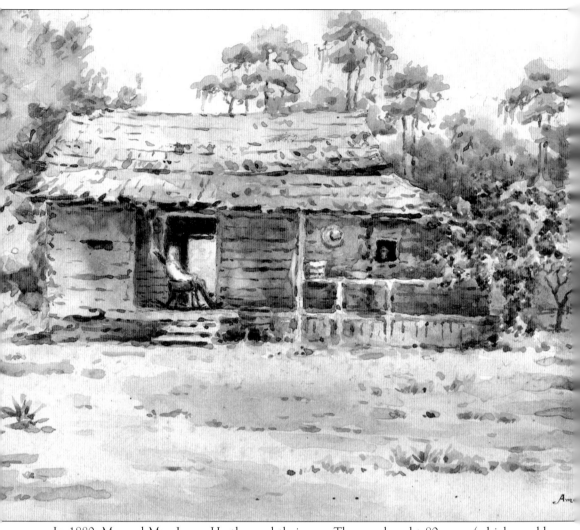

In 1880, Mr. and Mrs. James Hartley and their son, Thomas, bought 80 acres (which would today include Spanish Oaks) from Walton Whitehurst. The family lived for a time in this house on the property. This original watercolor painting, created by artist Amelia Watson, a winter visitor, shows James on the front porch.

IMAGES
of America

AROUND
PALM HARBOR

Winona Jones

ARCADIA

Published by Arcadia Publishing
Charleston SC, Chicago IL, Portsmouth NH, San Francisco CA

Printed in Great Britain

Library of Congress Catalog Card Number: 2004111798

For all general information contact Arcadia Publishing at:
Telephone 843-853-2070
Fax 843-853-0044
E-mail sales@arcadiapublishing.com
For customer service and orders:
Toll-Free 1-888-313-2665

Visit us on the internet at http://www.arcadiapublishing.com

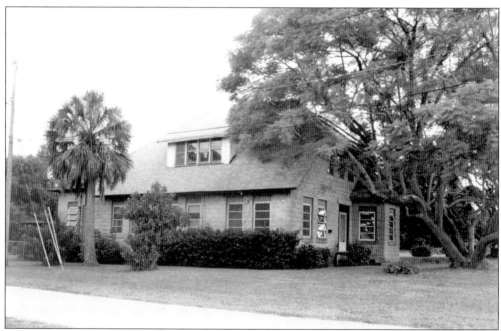

Several years after their marriage, Tom and Ida Hartley began construction of their block home. They lived there until their deaths in the mid-1950s. Their daughter, Lucy, returned to this home with her four children and continued to live there until it was sold to persons outside the family in the 1960s. In the early 1990s, the property was bought by Pinellas County and subsequently leased to the Palm Harbor Historical Society, which operates it today as the North Pinellas Historical Museum.

CONTENTS

ACKNOWLEDGMENTS

When the Palm Harbor Historical Society was incorporated in 1983, my husband and I were proud to become charter members. From the first official meeting, one of the society's priorities was to secure copies of personal photographs from the early families of the unincorporated region around Palm Harbor. Through the years, many families, individuals, society members, and society governing boards have earned our appreciation for assisting our efforts to collect and preserve the area's visual history. Society member Trudy Noxtine volunteered to collect and label each photograph. She thoroughly enjoyed this task; her care and concern continued until her death. Trudy always envisioned a work such as *Images of America: Around Palm Harbor*. She is very much a part of this effort: we recall her many hours spent collecting, copying, checking the accuracy of names, dates, and facts of each photograph.

Others who must be given thanks by name for their support include George Fulmer, a professional photographer who has worked with us for years, giving advice and counsel—as well as providing another vantage point on certain historic events in which he had been involved as a photographer. We owe much to this friend who loves our history as much as we do. Jenny Fortner began our entire research field of news, artifacts, etc. during her middle- and high-school years. True thanks go to Jenny as well for her excellent efforts gathering other photos and information in connection with the same project. Maryanne Brooks, a volunteer of long standing, answered the phone from the very first contact with our publisher; she has been a true friend throughout the entire publishing process. Amy and Bruce Kelley overheard my concerns about scanning all the photographs, and (like the true friends they are) quickly said, "We want to do that for you." That's what I call "neighbors and friends"! Special appreciation goes to our current Board of Directors, who gave their unanimous and outstanding support to the project.

To each and all of the above—and to others far too numerous to name—I give you my sincere thanks for your many hugs, concern, and support.

I cannot close without conveying my deepest love and gratitude to my husband, Charley, who has been my rock to lean on, to look up to, and to share our beautiful life with, for all these many years. Without his support, I would have never undertaken many of the "projects" that have enriched my life (and our family's lives) over more than 60 years.

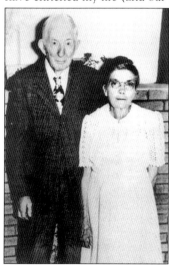

All of the author's proceeds from this publication will be used to establish a foundation for the museum.

Mr. Tom and Miss Ida, as they were lovingly known, pose in front of their parlor fireplace on their 50th wedding anniversary. This history is dedicated to them and to their love and commitment to this area.

INTRODUCTION

Today, few people in this, the most populous county per square mile in Florida, can imagine an area without homes or roads. There were once only rough trails from the north, east, or south, and water to the west. However, by 1850, some hearty pioneers had followed their dream, desire, calling, or adventure and began to inhabit this tranquil land. From the arrival of the first permanent settler until today, that movement has been unstoppable; in some aspects, the region scarcely contains any semblance of what once was. Our book attempts to provide a look backward, at why and how those settlers came here to make their homes, raise their children, and bring their culture to a strange land. We will cover those early years in photographs where pictures are available, especially from the late 1850s until the 1960s. As it is now defined, the Palm Harbor unincorporated area is bounded by Klosterman Road on the north, Curlew Road on the south, Bay St. Joseph/Sutherland Bayou on the west, and the Pinellas County line on the east.

William Lawrence Thompson and his wife, Julia Holland Thompson, are credited as the first permanent settlers in Palm Harbor, while Henry Tinny settled in Ozona. These two families, as well as others who settled on property there (including the Meyers, Rivieres, Joneses, Suttons, Nigelses, Dixons, and Ulmers), have many descendants throughout the 30–square-mile area. The various communities developed according to their particular environments: Ozona, or Yellow Bluff as it was originally called, became known for its fishing locale. The East Lake district grew to be a cattle and vegetable-farming area, while Crystal Beach and Wall Springs were famous for scalloping and other water activities. "Downtown" historic Palm Harbor matured thanks to its elevation above flood level and central location for newcomers; as a result, businesses started to build up in the vicinity. Long before 1900, citrus groves were being planted and began producing cash crops for the region. Citrus groves had already become the primary industry of the general area. It was *the* crop to plant on even less fertile land.

Each community retained its own unique characteristics through those very early years. An excellent attribute of all the communities, however, was that each recognized the independence of the other but also accepted their interdependence. The communities developed their individual traits while they acknowledged that none could ignore the special traits of the other areas. Only if they worked together could they co-exist and evolve.

According to historical records, the original 1888 plat of today's historic Palm Harbor was the first recorded development plat in Florida. The plat covered almost 1,000 acres, with the main thoroughfare of Florida Avenue 110 feet wide. Records show the original developers and inhabitants wanted a view and access to the clear water.

Historically, Ozona is the only one of the local communities to ever be incorporated. This occurred in 1915, but they saw the "folly of their way" and unincorporated in 1917. At present, no other community has seriously considered such an action; however, there are always those who have various reasons to suggest that a particular community should do so.

The other areas—Crystal Beach, Wall Springs, and East Lake—remain quite distinct and separate locales, but with that same sense of one overall "community." Preservation is alive and well today, and it is achieved through various entities: the Greater Palm Harbor Area Chamber of Commerce, whose first formal board was installed in 1977; the Palm Harbor Historical Society, officially incorporated in 1983, and its subsidiary, the North Pinellas Historical Museum; the even-longer running (and renamed) historic organization in Ozona, OVIS (Ozona Village Improvement Society); and several current preservation groups in Crystal Beach. Curlew boundaries are almost unknown because there were never any exact, historic boundaries or other clear identifying points to keep its name in place. Curlew was the name given to the creek, the church, and the cemetery. East Lake, basically a cattle-farming region,

did not start to become a populated community until the early 1970s. Until that time, it remained a district with one main road (made of sand and/or shell) and smaller unpaved roads out to individual family plots or land-use areas.

The year 1960 has, in retrospect, become a defining date for the rapid change that occurred in the Palm Harbor region. As is often revealed through history, there were two closely-related events that happened almost simultaneously and caused tremendous change. The first consisted of a series of catastrophic citrus and fishing freezes. Within a six-year span, from 1957 to 1963, complete citrus groves were either wiped out or so severely damaged that the subsequent, second event made it impractical to continue that agricultural endeavor. Until those disastrous years, you could drive in February and March from one end of the county to another without leaving the sweet smell of citrus blossoms. Now that scent is nearly nonexistent, and citrus groves have been converted into one subdivision after another. Many people do not realize that some species of fish are likewise susceptible to freezing temperatures. The "Crackers" (Florida natives) had heard of fish freezing in the late 1800s but had not seen it happen in their lifetimes—until this six-year period, that is. People were scooping up those fish that were alive but stunned, planning to clean and freeze them for future use; other fish were hauled to the groves to be used as fertilizer. As a result of this series of weather-related problems, both the citrus growers and those connected to the fishing industry suffered severe economic losses.

The second related event was a countywide and statewide increase in property taxes. Both state and county taxing entities found themselves in the predicament of facing population growth without the funds to meet demands for services—including roads, recreation, potable water, and schools. Under the new property taxes, people with acres of land but no active, profitable grove or business could not afford to wait an additional four to six years for new fruit trees to grow and become income producers. The only viable solution for most was to sell. Hence, grove after grove soon disappeared and were replaced by either subdivisions or a strip mall.

Around the same time, the state had also begun a massive, nationwide advertising campaign to entice people to move to (and not just visit) Florida. Pinellas County had served as a training area for every branch of the service during World War II. Some of these service people had already begun to move to the area. As regional growth developed, others saw new opportunities to combine business and pleasure. So, with the rapid influx of service personnel and other retirees, the entire landscape of property and population in the area changed dramatically.

It used to be that when locals would go to other cities to shop or go to a movie, they would always see a friend and actually stop to talk. Unfortunately, the friendliness and courtesy, which had always been such a normal way of life for the area, were beginning to disappear. We want you to know and appreciate our paradise. We are all neighbors, regardless of how we arrived. May we so remember!

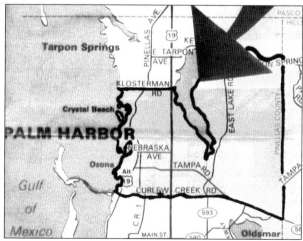

This map is taken from an early map printed by the Greater Palm Harbor Area Chamber of Commerce. We, and they, cover over 30 square miles of unincorporated land in North Pinellas County.

One

THE HERITAGE BEGINS

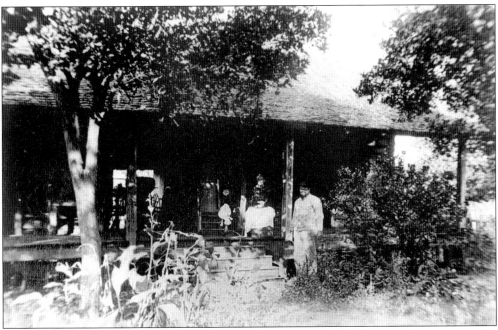

The W.L. Thompson family is credited with being the first family to truly settle in this uninhabited area. Of course, they had to clear land to raise food for the family even as they struggled to build a home. They moved into this log cabin in the early 1860s. Notice the buggy in the hallway or "dogtrot," as the pioneers called it.

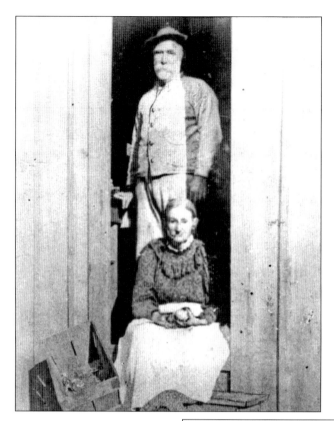

The owners of the log cabin, William Lawrence Thompson (1832–1908) and Eliza Thompson (1832–1907) stand at the back door of the cabin they built. These early settlers told their children tales of listening to wolves and other wild animals in the night. Despite the disturbance, the long, hard work days in which they both participated made sleep easy.

By the late 1890s, many more families and businesses had moved into this area. The ruts on the south lane of this photo lead from Bay St. Joseph eastward to the San Marino Hotel, which was built by Henry Plant in 1885. Today, this lane is Palm Harbor's Florida Avenue. The Gulf View Hotel (with cupola), which is among the trees on the left, was built around 1880 on the northeast corner of Florida Avenue and the Dixie Highway (Alt. 19).

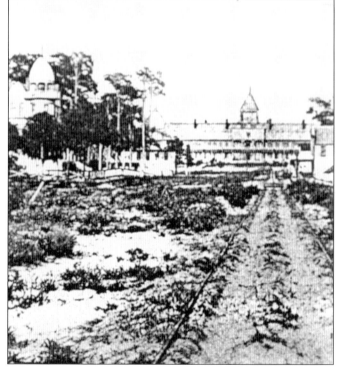

J.C. Craver created his second general store when he moved the Sutherland Post Office to the rear of his new building and kept the store merchandise in the front. He lived above the store until the building was bought by the Masonic lodge in the early 1930s; it remains their lodge building today with the downstairs all enclosed.

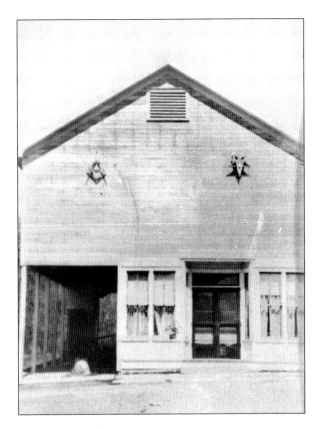

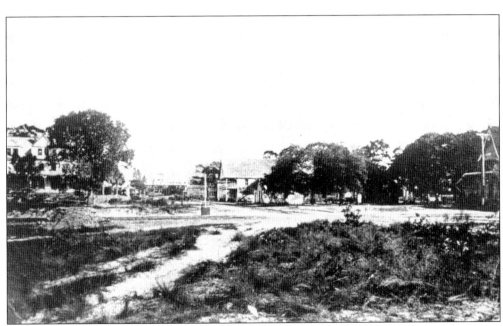

This slightly later photograph of Florida Avenue in Sutherland, *c.* 1905, looks eastward from the railroad.

Hog Island, shown here in 1905, was a large island in St. Joseph's Sound that was used by early pioneers as an excellent fish camp location, as well as an area to raise hogs. The hogs could move freely throughout the island, giving it its early name. The hurricane of 1921 split the island into two islands; therefore, today we have Caladesi and Honeymoon Islands, with Hurricane Pass separating them.

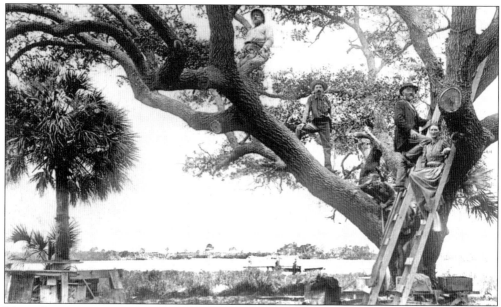

Mr. and Mrs. Henry Scharrer received a title to 160 acres on the southern portion of Hog Island under the Homestead Act. Their daughter, Myrtle, was named after the island's wax myrtles. Unfortunately, Mrs. Scharrer died after a lingering illness when Myrtle was six years old. Father and daughter continued to live on their "paradise" until after Myrtle's marriage years later. Many people during these years visited their home, often taking advantage of a tree perch to observe the Gulf and the coast in both directions. Until her death in the mid-1990s, Myrtle remained a devout nature lover—loving both her animals and open spaces.

In the late 1880s and early 1890s, Dr. George Fechtig, an osteopath, visited Florida and began buying land.

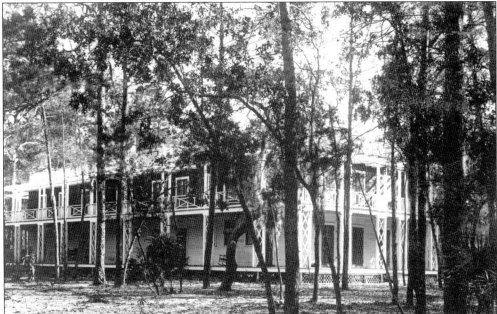

Around 1893, Dr. George Fechtig bought 500 acres of grove and non-cleared land from Aaron Dixon, an earlier settler. Fechtig built the St. George's Sanitarium, another lodge, and additional cottages on the undeveloped property. An initiatory exercise trail with stops and equipment at definitive points was included for patients and guests to use. These facilities were also available for use by the Boy Scouts, YMCA, and other youth groups. Dr. Fechtig died at age 70 of heart disease, and the land was subsequently divided and sold.

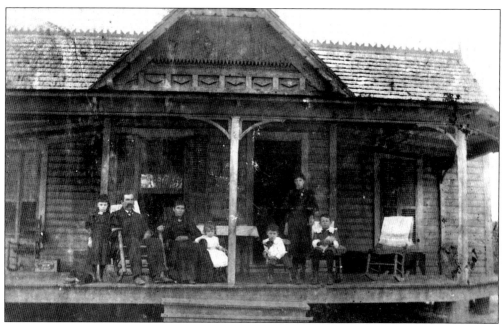

Descendants of the Johnson family, another early family to arrive in this area, pose on the front porch of their home on Mississippi Avenue in Ozona. The two seated adults are and William Lewis Johnson and Sarah Rebecca Holland Johnson; their children, from left to right, are Sadie Johnson (Kersey), Ethel, Will, Minnie, and Lewis.

Edith Newman, of St. Petersburg, visited relatives in the East Lake area. Notice the pitcher pump on the back porch, which supplied the water for the house and probably a vegetable garden nearby. The mesh around the bottom of the house kept the chickens from nesting underneath, while also attempting to prevent wild varmints from going under the house. Houses were built up off the ground not only to keep pests out but also to allow air to circulate under the house. This helped cool it in the long summer months.

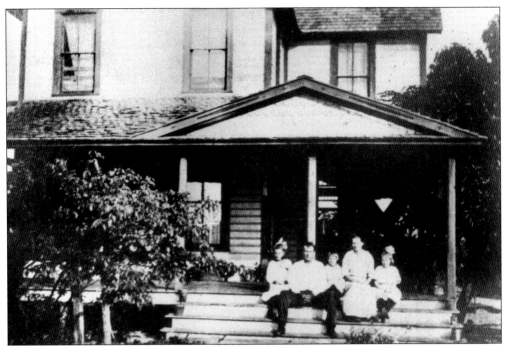

The George A. Thompson "Big House," built around 1910, was the home of the son of W.L. and Eliza Thompson, the early pioneers of the Sutherland (Palm Harbor) area. As seated, from left to right, the family members with their ages are Sarah Isabelle (10), G.A. Thompson (44), Julia Ella (4), Laura Thompson (28), and Myrtle Eloise (6).

The J.M. Jenkins residence, located at 1003 Virginia Avenue in Sutherland, was built in 1916 by Jenkins's uncle, J.T. Bruce. Notice the spaced boards around the bottom of this house rather than the more common chicken wire—one difference between the "farm" homes and the "city" homes. The original home is no longer there, but Jenkins's son, Jim, and his family have built another home at the location and continue to live there.

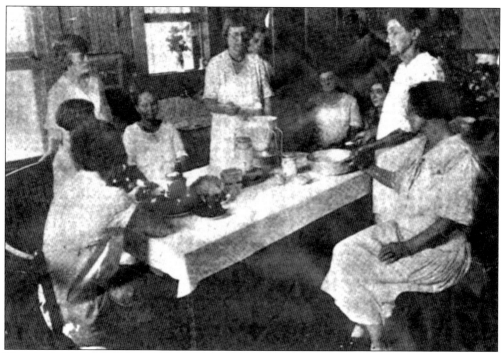

The Curlew Home Demonstration Club members learn the food values of milk and cheese, as well as the values of combinations with fresh fruits and vegetables. Members in this group include Maude Whitworth, Ludie Beckton, Mrs. Whitworth, Sadie Johnson Kersey, and Janice Grider.

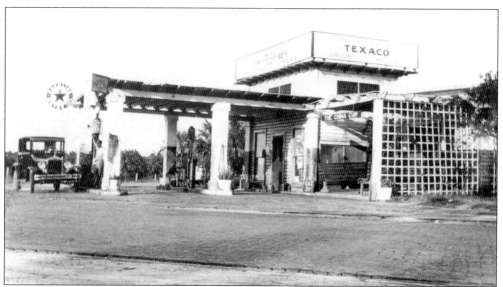

The Cross Roads Gas Station, built by Ed Bulloch around 1924 (two years prior to this 1926 photo), was located on the southeast corner of County Road 1 and Tampa Road, back when both were only two lanes. Notice that County Road 1 clearly shows the brick used in its construction. The older daughter of Judge Thomas and Ida Hartley, Lucy Hartley Barry, lived here with her husband and family and ran the station for a time. The building was torn down in 1976.

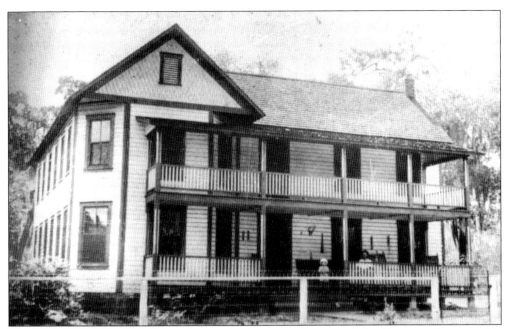

This is the home of the Phillip Sutton family—son of pioneer John Sutton, who gave this particular area the name Curlew. Again, notice that the entire house and yard area are fenced and that the house sits well off the ground.

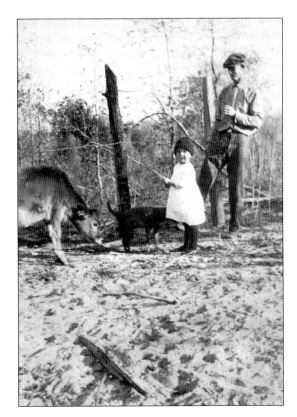

Lillian Lane (Dunlap), about three years old, and her father, Gratt Lane, feed one of their cows. Their home, near where this photo was taken, was located where Lake St. George Elementary School is found today.

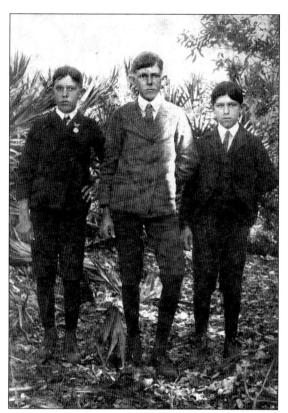

These three local young men, brothers Elmer and Merrick Daniels and Will Johnson, are photographed at a Sunday outing. Elmer became a Pinellas County road foreman and a game warden for many years. Merrick served as a deputy sheriff and a commercial fisherman. Will opened a general store on North Fort Harrison Avenue, Clearwater, near the Bank of Clearwater, which he ran successfully for several years.

A younger gentleman, Bob Fulford, enjoys the same Sunday outing with a group of young ladies. The young ladies seated are, from left to right, Belle Bishop, Minnie Johnson, Alice Tedder, and Permelia Pratt. The young lady standing is Sadie Johnson, sister of Minnie and Will (in the photo above). The Johnsons' father had homesteaded property in the Palm Harbor area; these Florida palmettos were close to that home.

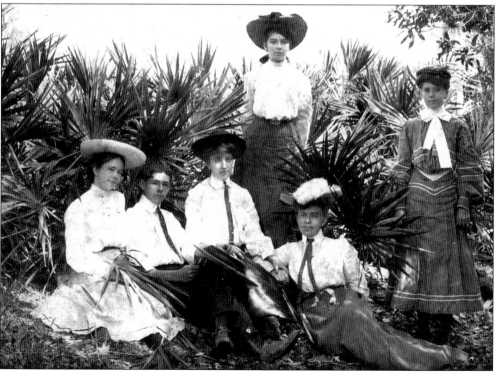

George Washington Kersey and Sadie E. Johnson Kersey, married on January 1, 1911, posed for this photo either on their wedding day or shortly thereafter. Together, they became one of the large citrus grove owners in the area. Mr. Kersey was respected as an outstanding leader in the community, especially in education; he fought with "dogged determination and untiring efforts" as a Pinellas County School Board member to have Palm Harbor Junior High School built. The school building, which also served as a community center, still exists today as Palm Harbor Elementary School.

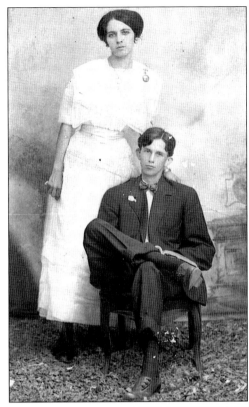

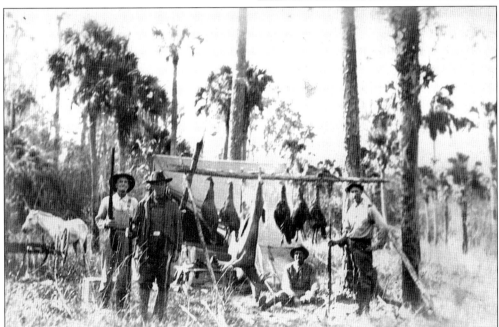

This photo reveals just some of the wild game that was available for the taking for many years. Deer and turkey were found throughout the area, along with an abundance of bird species, rabbits, and fox squirrel.

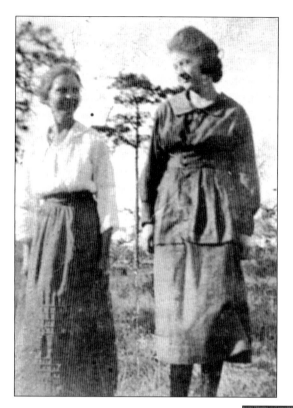

Sisters Mattie (around age 21) and Blanche Meyer (15) enjoy a Sunday afternoon at their home located on Meyer Lane at the northern side of Lake Butler (now known as Lake Tarpon).

Eugene Arthur Nigels appears here with his first car, a Model T Ford. He delighted to relate how, when he was dating his future wife, Bertha Lillian Dixon (who lived in the East Lake area), the steering wheel would come off as he drove over the "bridge of logs" placed across Brooker Creek on East Lake Road. Luckily, the sand ruts were so deep that the car continued to move straight forward until he could replace the steering wheel. He would then continue on to where Bertha heard the car and was waiting to welcome him.

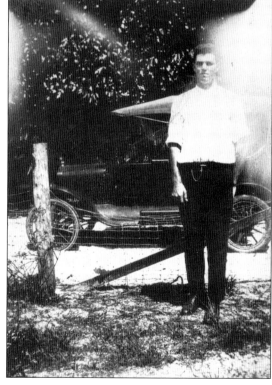

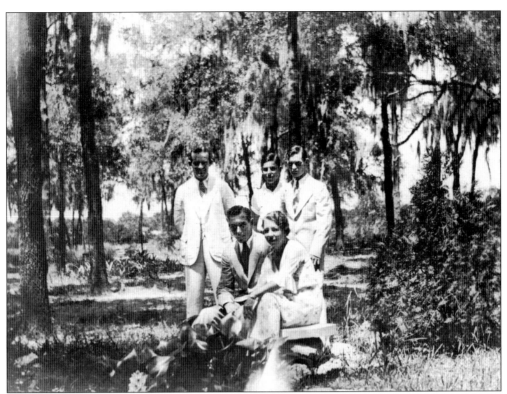

Members of a local family and two visitors enjoy a Sunday afternoon in the late 1910s or early 1920s. Seated are Wilson Nigels and his mother, Agatha Adams Nigels. Standing are two unidentified young men with David Nigels in the center. Notice the citrus trees in the far background, probably a part of Grant Groves. Citrus groves also surrounded the Nigels family home and yard, part of which is shown here.

The Russell Jones family gathers for a holiday picnic. The oldest son, Alvin, holds an unidentified cousin. The man standing to the left, whose face is obscured by his cap, is Leland; sister Katherine (Vought), stands to his front with younger brothers, Earl in front and Alfred to the right. The lady to the left is unidentified: she may be their mother, Susie, or one of her sisters-in-law. Family members believe this photo was taken at a picnic area on Jerry Branch or on Curlew Creek, both of which were utilized for picnics and swimming.

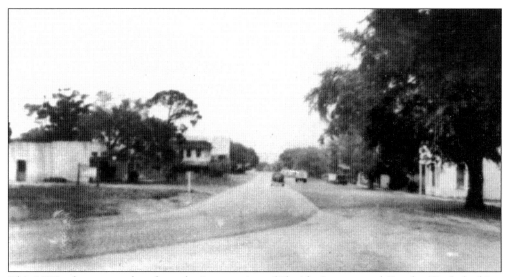

This 1930s photo was taken from the intersection of Florida Avenue and Omaha Circle looking west. The building on the near left was the Palm Harbor Post Office, with family living quarters in the rear; today this building is Iris & Ivy. The building on the right remains the Masonic/Eastern Star building. Omaha Circle is in the foreground. The main brick road was U.S. 19 at that time.

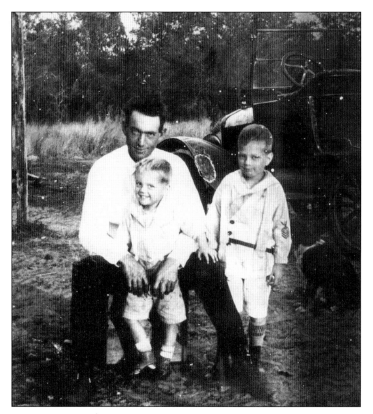

In the late 1920s, this family was on their way to the Curlew Methodist Church from their home on Nebraska Avenue in Palm Harbor. Charles L. Jones (1894–1968), poses with his arms around his sons, Charles Albert Jones (born 1924) and Robert Ernest Jones (standing, 1922–1986). The father was born in Ozona and lived here all of his life, with the exception of his military service in World War I.

George Andrew Thompson (1896–1937) and Laura Isabell (Curry) Thompson (1885–1976) appear in front of their Palm Harbor home in 1937, just a few months before George's death.

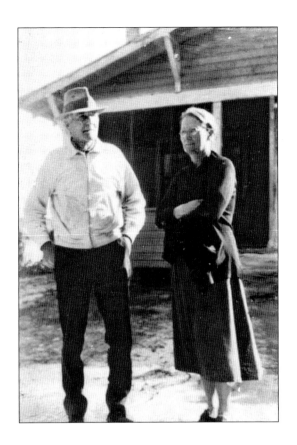

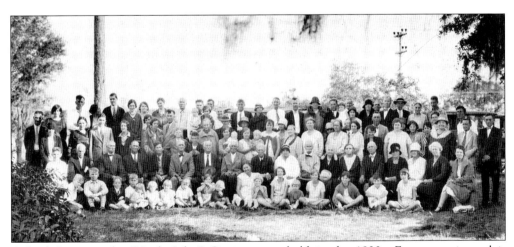

A birthday party for "Uncle John" Garrison was held in the 1930s. Everyone pictured is connected by family. Uncle John, a descendant of the early Garrison family settlers, was related by marriage to both the Sutton and Jones families.

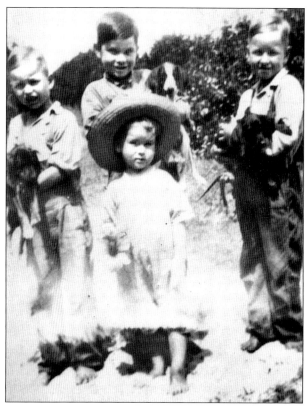

Three of the young Sutton men show pride in their pet dogs while a younger family member joins in. They are, from left to right (front) Richard Sutton, younger brother of Wallace and Howard; (back) Wallace, cousin Charles, and Howard Sutton.

Service Charge $1.00 (Pd)

FLORIDA POWER CORPORATION
CERTIFICATE OF DEPOSIT

B Nº 8399

DEPOSIT $ 5.00 DATE January 31, 19 47 FOLIO 18

RECEIVED OF Jones, Charles A.

STREET Route #1 CITY Palm Harbor, Fla.

THE SUM OF Five and 00/00 DOLLARS

AS A DEPOSIT TO SECURE THE FLORIDA POWER CORPORATION FOR THE PAYMENT OF ALL BILLS DUE AND TO BECOME DUE.

THE AMOUNT OF THIS DEPOSIT WILL BE RETURNED WITH INTEREST AT 2 PER CENT PER ANNUM UPON PAYMENT IN FULL OF ALL INDEBTEDNESS OF THE DEPOSITOR TO THIS COMPANY, OR WILL BE APPLIED TO THE LIQUIDATION OF SUCH INDEBTEDNESS.

THIS RECEIPT IS NOT NEGOTIABLE OR TRANSFERABLE. PRESERVE THIS RECEIPT TO BE SURRENDERED WHEN DEPOSIT IS RETURNED.

FLORIDA POWER CORPORATION

BY A. P. Beckett

	YEAR	MONTH	DAY			
REF. DATE					DATE	19
DEP. DATE				RECEIVED THE SUM OF	IN ADJUSTMENT OF THIS RECEIPT.	
INT. PERIOD						
MOS. @ $				(SIGNATURE OF DEPOSITOR)		

An original receipt from the Florida Power Corporation shows that electricity was secured for a home in Palm Harbor in 1947. Since members of this family have continued to live on the same property until this day, they have never requested the refund.

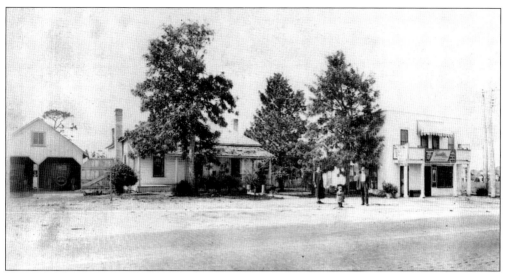

The William Ulmer home stood next door to his store, which was located on the southwest corner of Michigan and today's Omaha/County Road 1. The house, home of Rheba Ulmer (Sutton) until her marriage to Richard Sutton, remains today and continues to welcome winter visitors each season. The store provided many of the supplies for the San Marino Hotel and the Southern College. Although now gone, the store is remembered by many of the older members of the community and former students of the college.

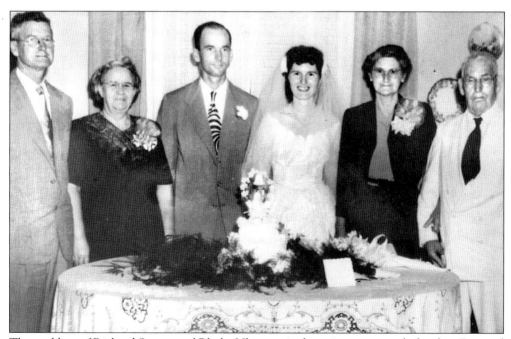

The wedding of Richard Sutton and Rheba Ulmer united two important early families. Pictured from left to right are Mr. and Mrs. Fred Sutton, the newly-wedded Mr. and Mrs. Richard Sutton, and Mr. and Mrs. Will Ulmer.

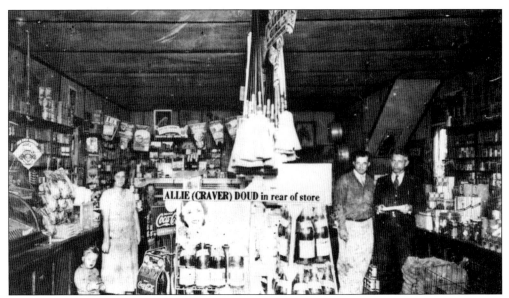

ALLIE (CRAVER) DOUD in rear of store

People from throughout the region knew they could quickly pick-up needed items or "stay a while" and chat at the Adair store. Both Mr. and Mrs. Adair, more commonly referred to as Dewey and Connie by all "Crackers" (native Floridians), were well known and active in all community affairs.

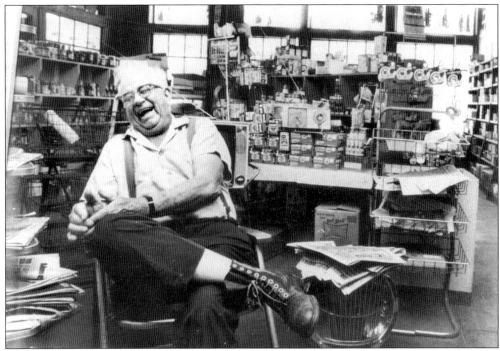

Dewey Adair served as the community's story-teller and benefactor. No local person ever left his store without a story and their supplies, whether or not they had the money. Some customers took years to pay their tabs, while others probably never caught up; in most cases, however, the friendships were retained.

Sara Isabell Thompson (1903–1987), daughter of G.A. and Laura Thompson and granddaughter of W.L. and Eliza Thompson, is shown here in one of her dance costumes. There were many cultural opportunities for the region's young people, such as music, dance, and plays.

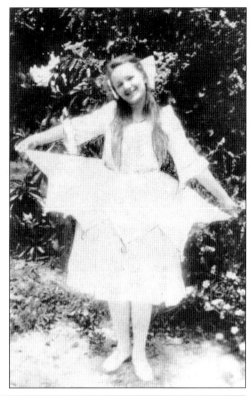

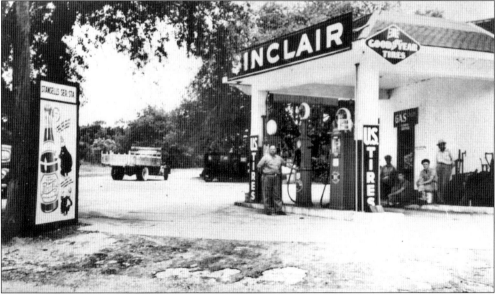

About 1945, Henry Sylvester Stansell stands by the pumps of his gas station located at the southeast corner of Alt. U.S. 19 North and Florida Avenue in Palm Harbor. "Pop," as everyone called him, was greatly respected throughout the area and the county. He was tragically killed while crossing Tenth Street (now Alt. 19) several years after this photo was taken. The "Pop" Stansell Park, located on the waterfront at the west end of Florida Avenue, was built and named in his honor by the community after his death.

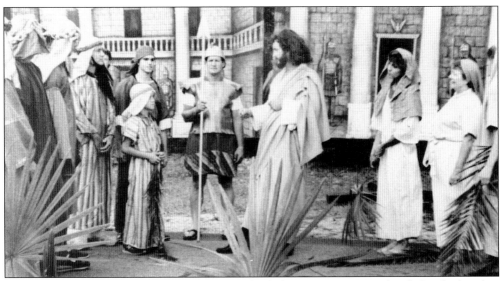

The Palm Harbor Easter Sunrise Service, which began in 1948 with all local churches participating, originally depicted scenes with costumed persons and natural landscaping only. Trudy Noxtine, a "Cracker" and an established artist, volunteered to paint appropriate scenery in 1969 after her return to the area following service in the War Department. The viewing public would bring their own chairs, while either the Masonic Lodge or another organization would provide coffee for this stirring service held at the top of the hill of Florida Avenue.

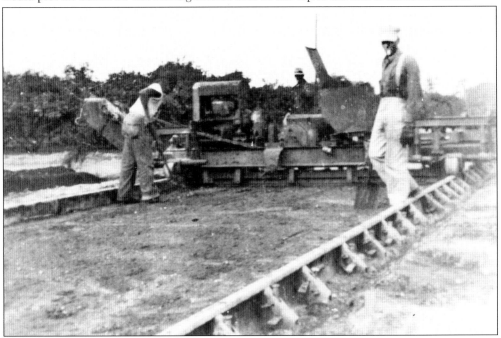

Tampa Road was widened in 1950 from a two-lane to a four-lane road, which was quite an exciting event at the time. In this photograph, taken from the Noxtine grove located on the south side of the road, the Wall grove can be seen in the background. Both groves were located between West Lake Road and Lake St. George Drive. Curtis Woodcock (not shown in the photo) was the caretaker of the Wall Grove.

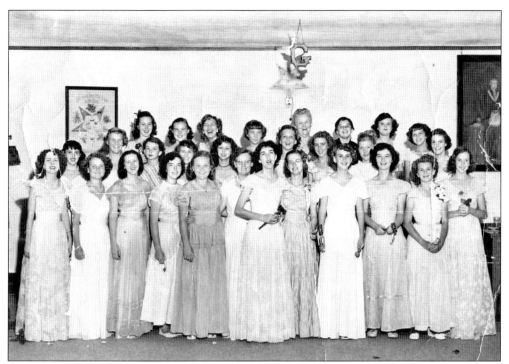

A fraternal order under the auspices of the Palm Harbor Eastern Star, the Rainbow Girls was made up of young ladies from the local communities. The older lady in the back row was the Florida State Grand Worthy Matron. The older lady in the middle/front row is Mrs. Lee (Ella) Nigels, the local chapter advisor. The others are unidentified.

In this *c.* 1941 photo, cousins Frederick Nigels (left) and Emile "Buster" Nigels visit with each other at Fred's home on County Road 1. Notice the building in back, which at the time was a fruit stand, as well as the Nigels grove background.

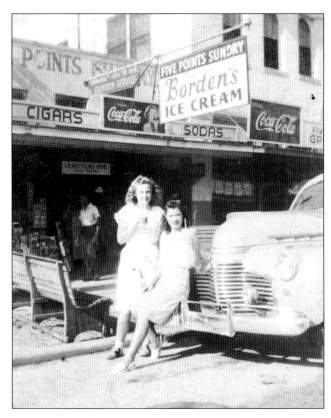

Depending on where they lived, young people of the area had to attend high school in either Tarpon Springs or Clearwater until 1962. These two ladies, students at Clearwater High, appear in this photo taken at the Five Point area just south of their school. Most students from outside the immediate Clearwater area had time to buy snacks and supplies, such as store-bought bread, while waiting for their bus. These two young ladies must have had their own transportation—a rarity in those days; one or both seem to have had items to purchase for their families that day.

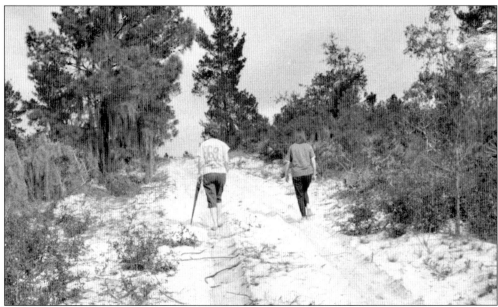

This photo of Alderman Road in the late 1950s may be unbelievable to people moving here since the 1980s and 1990s. A woman walks with her daughter up one of the sandy hills of the original Alderman Road. Hunting for that special holiday tree was a yearly family excursion; the annual ritual often included the husband or father pulling out people stuck in the "sugar" sand.

In the mid-1950s, the above-average spring rains played havoc with the area. Many groves were damaged and Curlew Creek was completely out of its banks. This photo shows county employees, as well as nearby residents, checking the bridge on County Road 1 just south of Curlew Road.

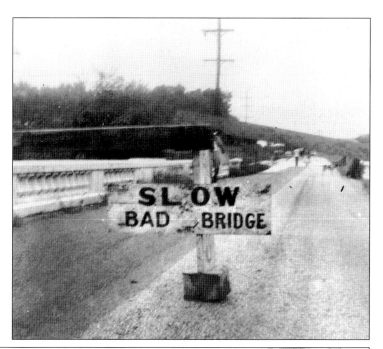

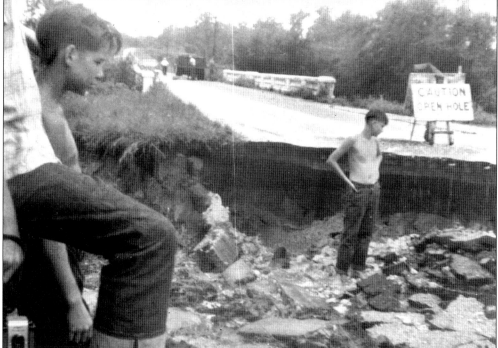

Young boys from the neighborhood check the damage created as the water continued its flow across the road. This "wash-out" at the north end of the bridge caused the road to Dunedin to close for several weeks, thereby putting all south-bound traffic onto today's Alt. 19. That road was a two-lane road with no traffic lights until downtown Dunedin. Even with less traffic than today, it made traffic much slower than normal. U.S. 19 as it exists today had not even begun to be built; in fact, two-lane County Road 1 was U.S. 19.

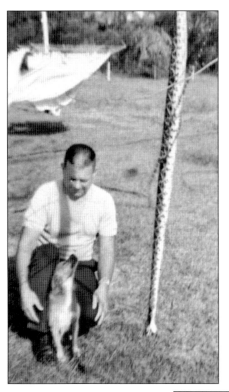

Even in the 1950s, there remained unwanted critters. This dog warned his owner, Charles Albert Jones, of a rattlesnake, which was promptly killed. (Fortunately for present-day residents, such incidents have become basically unheard of in this area.) This particular six-foot-plus snake had not been killed in the yard but in the pasture where the dog and his owner had gone hunting. The dog is obviously as pleased with his work as his owner.

The state-protected Florida Land Tortoise, called a "gopher" by the Crackers, is still seen occasionally. Certainly not dangerous, the tortoises provide a shelter in their burrows for themselves and many other critters (including rabbits, barn rats, and snakes) in the event of land fires. The burrows also provide seepage to the ground by collecting water during the rainy season. Unfortunately, some developers do not understand the tortoise's uniqueness and usefulness to our environment; they often ignore tortoise habitats and cover their burrows, killing them as they clear the land.

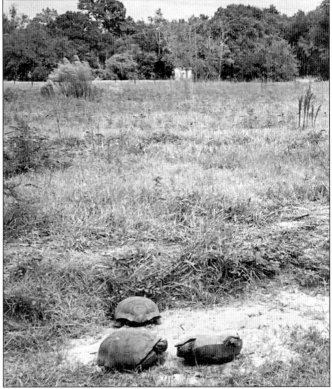

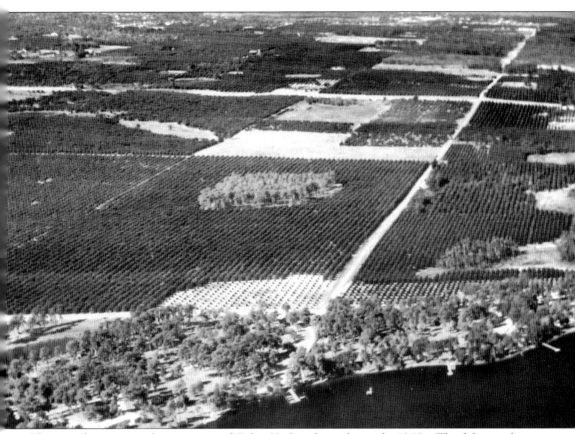

This aerial view reveals a portion of Palm Harbor from the early 1960s. The lake in the foreground is the southwest side of Lake Tarpon (Butler). The wooded area serves today as Cobb's Landing. The dock at the end of the road was the landing for early boaters. Mr. Cobb, whose home is in the left foreground, owned all the wooded land and much of the citrus grove directly above his home. Each of the more recently planted citrus trees replaced mature trees lost in earlier freezes. Barely visible in the far upper left, the Dunedin Causeway goes to Honeymoon Island, which had just begun to be dredged in. Farther along the top of the photo are Ozona, Palm Harbor, Crystal Beach, and Wall Springs. The intersection in the upper right is today's Alderman Road and U.S. 19, both then used primarily to move citrus fruits from the groves to the packinghouses. Other grove owners in this particular location were the Fletcher, Riviere, Thompson, Henderson, Hamilton, and Noxtine families (among other groves not clearly identified). In the wooded area to the right of Alderman Road and extending to the lake, screened and outdoor picnic tables and grills were provided for community use for years. Of course, the land had not always been as manicured as in this photo, and houses were less common before this time. (The author actually learned to swim from the small white beach to the right of the landing dock and can remember the thrill of being able to swim to the diving platform for the first time.) All churches, schools, scouts, and individuals were welcome to use the facility on a first-come basis without charge. It was Mr. Cobb's daughter, Mrs. Jane Cobb Shelnut, and granddaughter, B.J. Shelnut Maloney Cash, who legally established (with family friend Peter Hills Monroe) the Historical Society of Palm Harbor in 1983 and, consequently, the first North Pinellas Historical Museum in 1983.

Scenes such as this one were common from the late 1800s through the 1950s. This particular citrus grove, located in the Curlew area of Sutherland (now Palm Harbor), is highly representative of the area.

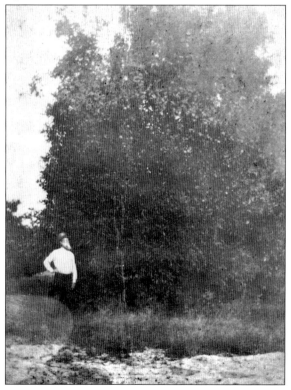

William Frederick Nigels stands by one of his orange trees. A news clipping of that day tells that he came to the area as a young man, traveling from Canada throughout the Western Hemisphere until going to South Carolina. There he served under Colonel McCullough in the Civil War and married Harriett McCullough. After husband and wife both taught at Judson College for Women in Alabama, they arrived in Florida in the mid-1860s. Looking for good citrus land, they settled in this area and homesteaded a total of 160 acres on County Road 1—some portions of which had already been planted in citrus. This pictured tree is a seedling, a tree raised from seeds of the particular orange or grapefruit; though taller and with many thorns, seedlings are nonetheless as sweet as the original fruit would have been.

Two
CITRUS GROWTH
AND DEMISE

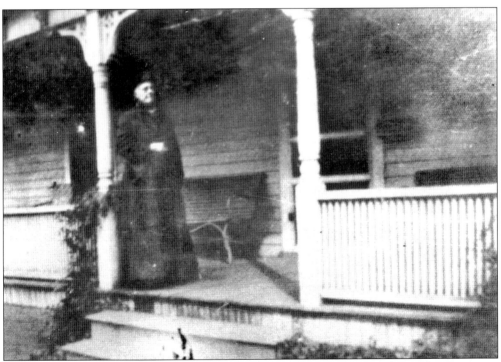

Mrs. Harriett Shumate McCullough Nigels stands on one of the porches of her home on County Road 1. All the lumber for this home, as well as for Deer Hall (a home later built by her son, Arthur, which still stands on Virginia Street in Dunedin), was shipped from South Carolina by Mr. and Mrs. W.F. Nigels. A South Carolina oak tree remains on this property on County Road 1.

THE UNITED STATES OF AMERICA,

To all to whom these presents shall come, Greeting:

Homestead Certificate No. 540

APPLICATION 2334 } **Whereas** There has been deposited in the General Land Office of the United States a Certificate of the Register of the Land Office at _Gainesville Florida_, whereby it appears that, pursuant to the Act of Congress approved 20th, May, 1862, "To secure Homesteads to actual Settlers on the Public Domain," and the acts supplemental thereto, the claim of _William F. Nigels_ has been established and duly consummated, in conformity to law, for the _East half of the North East quarter of Section twenty three in Township twenty eight South of Range fifteen East in the District of lands subject to sale at Gainesville Florida, containing seventy nine acres and eighty one hundredths of an acres_

according to the Official Plat of the Survey of the said Land, returned to the General Land Office by the Surveyor General:

Now know ye, That there is, therefore, granted by the United States unto the said _William F. Nigels_ the tract of Land above described: **To have and to hold** the said tract of Land, with the appurtenances thereof, unto the said _William F. Nigels_ and to _his_ heirs and assigns forever.

In testimony whereof, I, _Ulysses S Grant_, **President of the United States of America,** have caused these letters to be made Patent, and the Seal of the General Land Office to be hereunto affixed.

Given under my hand, at the City of Washington, the _first_ day of _July_, in the year of our Lord one thousand eight hundred and _Seventy five_, and of the Independence of the United States the _ninety ninth_

BY THE PRESIDENT: _U S Grant_

By _S D Cone_, Secretary.

_____, Recorder of the General Land Office.

Recorded, Vol. _1_, Page _276_

In this photo, William Frederick Nigels's original deed showed his purchase for a portion of land under the Homestead Act following the Civil War. He had purchased an adjoining parcel to create a total of 160 acres. The property began at today's Michigan Avenue, where the North Dunedin Baptist Church is located on the southwest corner, and went south to today's Salon Drive and west to (approximately) a block east of Pinehurst. Mr. Cereolo owned much of the land where Dunedin High School is now located and raised excellent vegetables on that rich land. Because of the type of land in the western portion of the Nigels property, it was also used for vegetables and cattle.

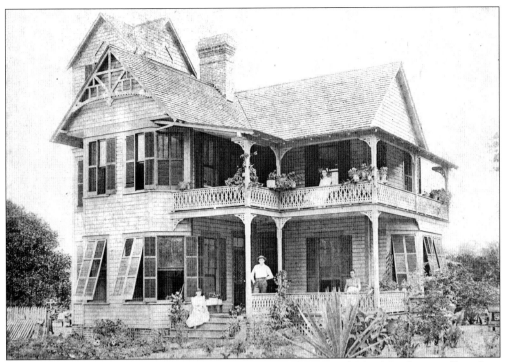

A full view of the W.F. Nigels early 1900s home reveals Mr. and Mrs. Nigels, as well as their two daughters, Ida and Clara—one sitting on the steps, and the other on the upper porch. On the back of this photo is a handwritten notation: "W.F. Nigels home built about 1905 or earlier as I, Eugene A Nigels, remember when some building was in progress there. Eugene A. Nigels, Dec. 3, 1970." E.A. Nigels was born on October 31, 1900, and would often show this photograph and others to his children as he talked of their family's history.

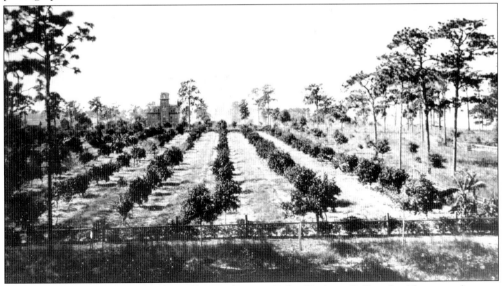

This small grove was north of the college in historic Palm Harbor. College buildings can be seen in the background. At one time, there were groves with peach trees, apple trees, or grape arbors placed between the citrus trees as a test for the University of Florida Agricultural School.

Benjamin Franklin Meyer and his son, Raymond Albert Meyer, work on their grove in the northeastern part of the county in 1912. Although citrus can be seen in the background, we were told that father and son were in the process of adding more citrus trees to their land holdings in this photo. Incidentally, there are two mules pulling the wagon; there appears to be only one without looking closely.

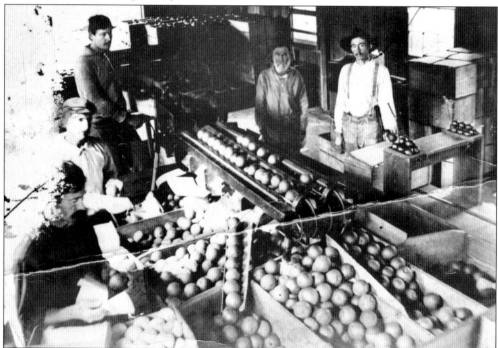

A photo of the Rogers & Wills Grove Packing House sometime in the 1880s shows the following people (from left to right): George Whitehurst, Cab Whitehurst, Oscar Thompson, G.A. Thompson, and unidentified. The small packinghouse allowed one or more smaller citrus growers to work together, helping one another with the many phases of work necessary to keep their groves and shipments moving smoothly through the entire process.

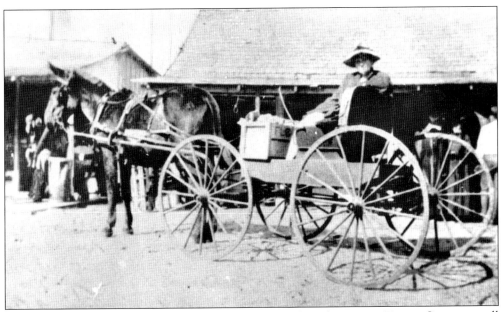

Mrs. G.A. Thompson thought nothing of taking the mule and wagon to Tarpon Springs to sell their fresh citrus and (in return) to buy the supplies needed for both home and grove. This photo from 1913 shows her at the sponge docks ready to sell her produce to residents or visitors.

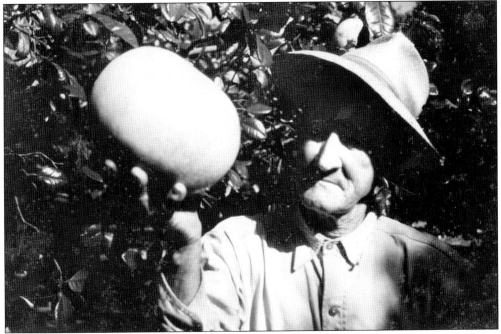

Lewis Beckton shows off one of his prized fruit—from the grapefruit family—called a "shaddock." This fruit, which is much larger than a regular grapefruit, has a very thick peel that is prized for making candied preserves. The meat of the fruit is also very distinctive, adding a different texture and taste to salads. Because very few people today know of them, shaddocks have almost become extinct; nonetheless, they can continue to be found with some research and information from Florida Crackers.

This barn is typical of those found on most of the farms or groves. In this particular barn, the left side contained a small room for animal feed storage as well as one or more milking stalls. Young people were usually taught to perform the task of milking and knew that it must be completed both morning and evening. At the north end of this barn were separate stalls to feed the mules or horses—whichever one, or perhaps both, that the person was able to afford. The right side of the barn was open, but there was protected space for equipment storage and maintenance. Hay, usually raised on the pasture land or in the open space between rows of citrus, was stored in the upper floor of the barn. The main floor of the barn was for storing, repairing, and cleaning the myriad tools and equipment regularly used on a grove or farm. The barn in this photo remained in use until the property was sold in the mid-1970s. The two men pictured are brothers Eugene and Lee Nigels, grandsons of the original owner, William Frederick Nigels.

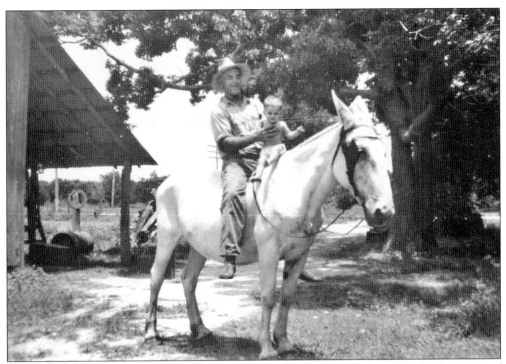

This photo shows Eugene Nigels with his grandson, Charles Eugene Jones, on "Mike"—one of the family's grove mules. If the mules had been broken for riding and had not been used for grove work for a few days, they were often used for pleasure riding or hunting. This grandfather was very carefully teaching his grandson not to fear the animal.

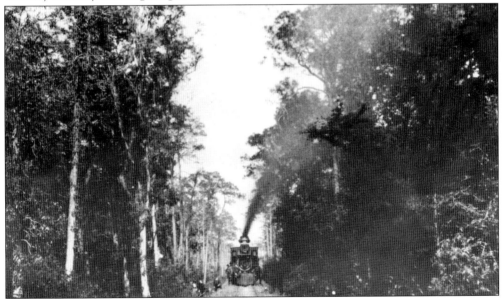

By the late 1870s, there were enough people and merchandise throughout Florida that various railroad companies began to consider bringing more rapid transportation to the state's west coast. Forests had to be cleared for the right of way, while sloughs, lakes, and rivers had to be bridged. Here in this photo, some of that work is being carried out.

STATE OF FLORIDA,
Hillsboro COUNTY.

Know all Men by These Presents,

That *William F Nigels and Harriet S Nigels his wife who joins him in this deed* — of the County of *Hillsborough* in the State of *Florida* for and in consideration of the sum of ONE DOLLAR, to *us* in hand, paid by the corporation of the State of Florida, the **Silver Springs, Ocala and Gulf Railroad Company**, the receipt whereof is hereby acknowledged; and the further valuable consideration of the enhancement in value which will accrue to *our* neighboring or adjacent property in consequence of the construction and operation of the line of railroad of the said Silver Springs, Ocala and Gulf Railroad Company, have granted, bargained, sold, aliened and conveyed, and by these presents do grant, bargain, sell, alien and convey unto the said Silver Springs, Ocala and Gulf Railroad Company, all of that certain tract, piece or parcel of land situated, lying and being in the County of *Hillsborough* in the State of Florida, particularly described as follows, to-wit:

A piece of land being two acres deep East and West and five acres long North & South, being situated in the North West corner of the North East quarter of the North East quarter of Section Twenty eight Township Twenty eight South of Range Fifteen East —

{ Provided that a depot be located within one quarter of a mile of present residence of donor }

containing by estimation *Ten* acres of land, ~~more or less~~, together with all and singular the tenements, hereditaments and appurtenances to the same belonging or in anywise appertaining. **To Have and to Hold** the same unto the said Silver Springs, Ocala and Gulf Railroad Company, and to its successors and assigns in fee simple absolutely FOREVER. Provided, however, and this deed is executed and delivered upon this condition: That if the said Silver Springs, Ocala and Gulf Railroad Company shall fail to complete and have in actual operation its railroad to within _____ miles of the above described land at the end of *Two* years from the date of this deed, then such failure shall entirely defeat this deed and render the same wholly null and void.

In witness whereof *we* have hereunto set *our* hand *s* and affixed *our* seal *this* *15th* day of *September* A. D., 188 *6* —

Signed, sealed and delivered in the presence of us as witnesses.

_____ [SEAL]

_____ [SEAL]

1 Acre of Land = 208.86 ft. long & wide. hence the above 10 acres = 1044.30 ft. long x 417.78 ft. wide.

W.F. Nigels had traveled extensively by train and was captivated by their business and travel use. Therefore, he wanted the rumored railroad to be as close to his property as possible. This deed gave land for the needed right of way—provided it met his requirements. Sadly for him, the railroad magnates had their own plans, and the deed was ultimately returned to him.

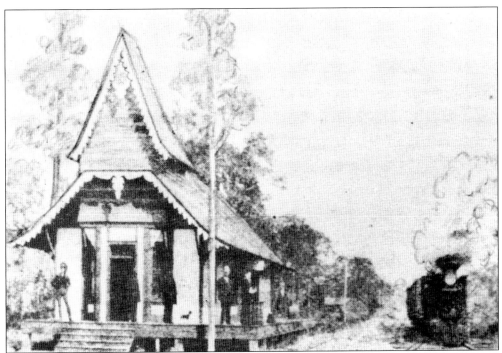

The Orange Belt Railway, a narrow-gauge track built through the area between 1885 and 1889, had its terminus at St. Petersburg. In 1890, Russian developer Peter Demens had this depot built at the northwest corner of Florida Avenue and Dixie Highway in Sutherland. Redevelopment plans for the area include a replica of the depot built as a rest stop for the Fred Marquis Pinellas Trail, which has since replaced the railroad.

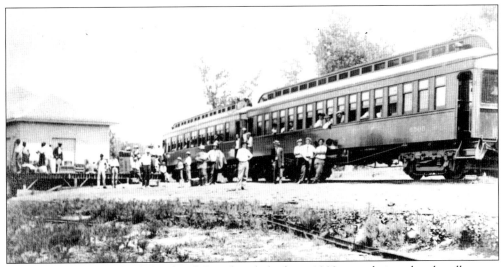

A second depot (on the left side of this photo), built in 1903, was designed to handle more freight, such as fruit or fish. The Plant Railroad System had converted the rail to standard track under their new ownership (1895–1902). In 1902, Atlantic Coast Line purchased the line and, in 1906, began a "short train" running from Tarpon Springs to St. Petersburg only; this short train was primarily used only for passengers.

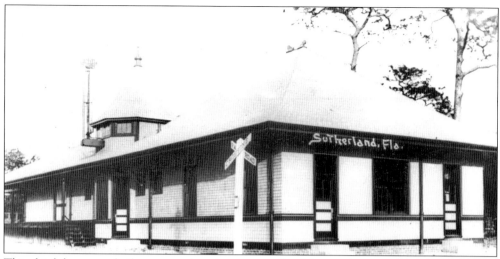

This third depot was built at a new location just north of the northeast corner of Virginia and Dempsey Road in 1917. Notice that the name "Sutherland" is still in use and that the cupola design remains the same. This building stood until all passenger and freight service was discontinued in 1984; it was demolished shortly thereafter. In 1990, the right of way became a sports trail, which continues to traverse the county.

In 1920, Eugene Hill was photographed picking oranges in his Curlew community grove. The ladder he stands on was made at the Hartley Ladder Factory, which was located (with plans for replication) on the large lot to the west of the present-day museum. The outer sides of the ladder were made from local cypress trees, while the rungs were made from the heart of a pine tree. These ladders were used throughout the western hemisphere until aluminum came into widespread use well after World War II.

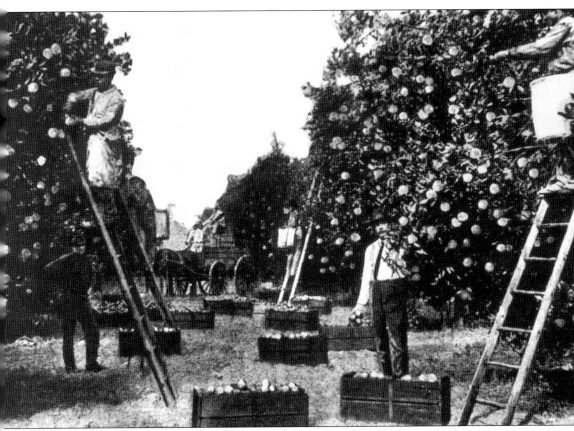

This vintage postcard showcases many facets of the citrus industry. To a grower or picker, it is obvious that the photographer has staged some aspects of the work. In the center is a horse-drawn wagon; this "in grove" vehicle would carry boxes of fruit to a larger vehicle placed around the perimeter of the grove. The boxes in the middle would be placed in straight rows nearly underneath the trees. The loading crew usually consisted of three people—two to place the heavy boxes of fruit (two bushels) on the vehicle's flatbed and a driver to slowly navigate the vehicle between the rows of trees. When the truck bed was filled, usually three or four boxes high, this vehicle would take the fruit to the larger truck before returning to the packinghouse. Notice how these pickers have the picking sack placed across their body. The picker on the left is clearly using clippers to pick the fruit, rather than "pulling," which was started much later. To pick fruit in any mode, the bag—which held a bushel—had to be secure and afford easy access. An experienced picker could rapidly fill a bag, regardless of method, in "good" trees such as these. As there is fruit further into the trees, a picker quickly learned how to place a ladder to pick the entire section he was working before moving to the next section. In larger groves, a picker might reserve a particular row, and others knew not to move into that row. A new picker would usually be delegated less desirable trees or rows. Of course, the foreman could assign either tree or row; however, most knew their workers and kept silent in such matters unless absolutely necessary. Each picker placed a paper marker on every box he picked, which determined his pay. At this time, a picker would not pick up any naturally dropped fruit; another crew might be hired to do that after the regular picking was completed. The long-sleeved shirts were for protection from thorns (or limbs) of the trees. Even the owner, foreman, or fruit buyer usually dressed in this fashion when working in the grove.

STATE OF FLORIDA

PINELLAS COUNTY

Received of E. E. Nigels

St. or R. F. D.

P. O. Address Palm Harbor

ROSS PRINTING COMPANY, TALLAHASSEE, FLORIDA—2510

In case receipt is spoiled, mark "spoiled," and ...

Tax Collectors Must Us

J. M.

The sum of Ninety One

In payment of State and County Taxes for 1935 on real a...

PAGE	LOT	BLK.	DESCRIPTION OF LANDS PAID ON	SECT.	TWP. S	RGE. E	ACRES	AGGREGATE VALUE	EXEMPT AGGREGATE VALUE	TOTA COU BO INT F
241			E ¼ of NE¼ of SE¼	13	28	15			360	
243			S 913' of NW¼ of SW¼ of SE¼ & S 898' of NW¼ of SW¼ E of Rd	24					1140	
244			Beg at NW cor of NW¼ of SW¼ run S & N 66' E+W 319'	25						
			PERSONAL PROPERTY							
			TOTAL							

NOTICE: Taxes are due and payable November 1 of each year.
DISCOUNTS: 4% if paid to County Tax Collector in November, or 3% if paid in December, or 2% if paid in January, or 1% if paid in February.
DELINQUENT: First Monday in April.

This Receipt must be returned for any necessary correctio 'before the end of month in which it is written.

NOTE: FOR FURTHER INFORMATION AS TO YOUR TAXES IN THIS CO

This original tax bill for citrus land (approximately 75 acres and home in Palm Harbor from 1935) seems miniscule by today's tax bills. Many grove owners, however, were losing their property because they could not pay their taxes. Even Temple oranges might only return a price

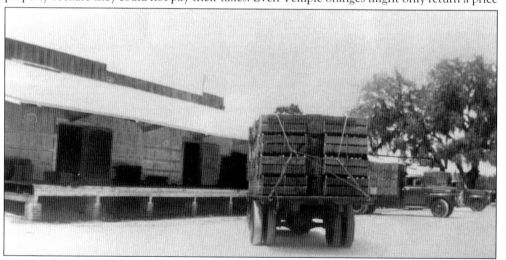

Coyt Walters, who contracted to haul fruit from the grove to the packinghouse, is shown pulling up in one of his trucks to the platform at the Palm Harbor Citrus Company Packing House in 1946. Notice other trucks, perhaps more Walters trucks or other contractors and grove owners, back up to the platform where a man with a two-wheeled "truck" would remove the boxes in four-box increments.

mbers must not be changed.

Only for Taxes of 1935

ller

_____ Dollars,

rty as follows:

	Dist. No.	Special Road Bond Dist. Int. & Skg. Fund	Dist. No.	NON-EXEMPT VALUE AS ASSESSED	STATE	COUNTY MAINT.	Dist. No.	Special School Bond Dist. Int. & Skg. Fund			Dist. No.	Special Road Bond Dist. Int. & Skg. Fund			AGGREGATE TAXES
40	8	1116													1962
10		3534													6213
				140	77	515		350			8	462			1400
															9575
												490			383
														$	9192

Date _____ 11-22 , 1935

D.C. Wielderman

THE TAX COLLECTOR WHOSE SIGNATURE APPEARS ON THIS RECEIPT.

Tax Collector for Pinellas County. Clearwater, Florida.

of $1 per picked box for this five-acre section. The owner would probably receive no more than 50¢ per picked box for his grapefruit and other oranges. This grower was fortunate that he could earn such prices and retain his ownership.

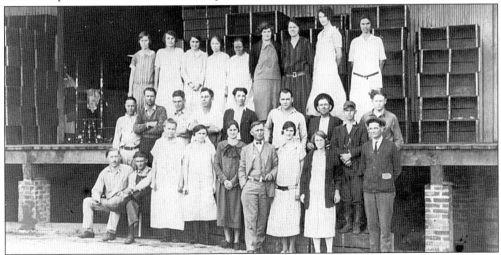

This packinghouse crew of 1927 includes all the positions within a typical packinghouse. The women were the packers, while the men include the house supervisors, those unloading the grove truck, and others who saw that the fruit was moving properly throughout the house—including washing, waxing, grading, and packing. Each person had a very specific job from the time the trucks first arrived until the fruit was on the shipping platform.

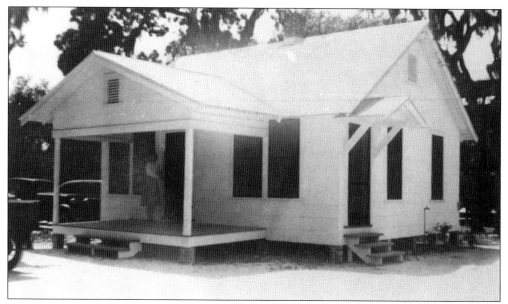

By 1930, the Palm Harbor Citrus Growers Association had been formed. This office building, located on the original site of the earlier Manatee Packing Company (of which the packing facility can be seen in the background), was rebuilt for the new company. F.W. Moody managed this office until 1970.

In the late 1930s and early 1940s, H.L. (Lorimer) Stansell expanded his local fruit-hauling business to selected Northern markets. In this photo of driver Bill Allison, taken by his unseen partner, Allison is seen resting in North Carolina after hauling the truck and trailer of packed citrus to Washington, D.C., in 1941.

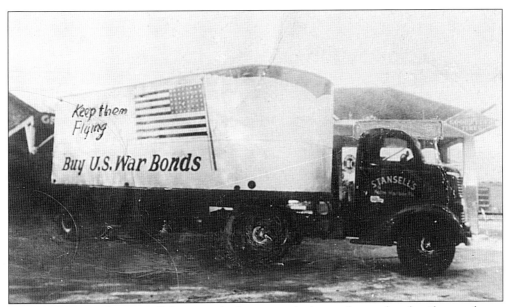

By World War II, the Stansell Company had grown and advanced to enclosed trailers, as shown in this photo. Through their trucks, they not only promoted the war effort but also began to "sell" the Palm Harbor name throughout the country.

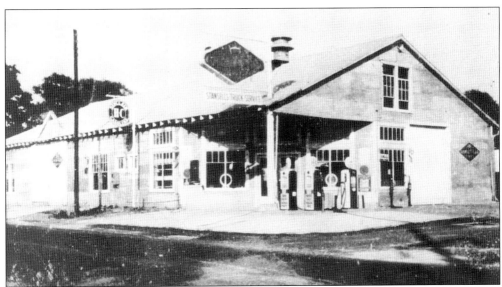

The original H.L. Stansell garage was built in 1933 to maintain not only the Stansell trucks used in local groves but also community vehicles. "Pop" Stansell operated the gas station portion of the business that serviced the entire community as well. The business was located at the northeast corner of Alt. 19 and Illinois Avenue until the mid-1990s, when it was moved to a new location further north on Alt. 19.

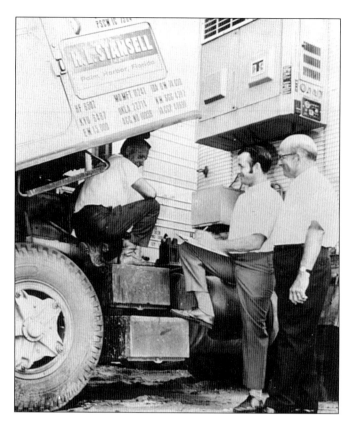

This 1971 photo indicates the ever-increasing equipment needed to maintain a company that conducted its business throughout the Northern Hemisphere. Working on this truck, from left to right, are Bill Williamson, brother of Mrs. Lorimer (Addie) Stansell; Bobby Stansell, son of Addie and H.L.; and H.L. (Lorimer) Stansell, owner.

Located between West Lake Road and St. George Drive in Curlew, the Tom Noxtine home on Tampa Road was built around 1920. Judging by the size of the trees in the photograph, the grove had been planted a few years earlier. Mrs. Tom (Alice) Noxtine holds her infant, Gertrude, who was born in 1924.

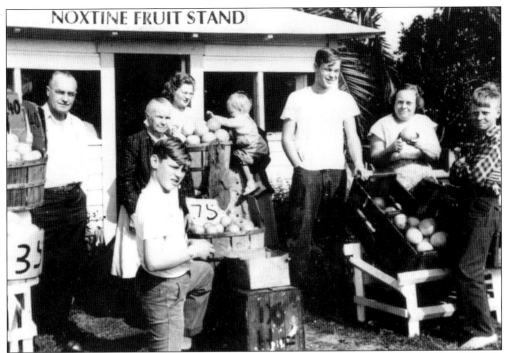

NOXTINE FRUIT STAND

In 1948, the Noxtine family operated this fruit stand close to their home on Tampa Road. Since it would take at least five years to harvest a crop of fruit from the 1919 grove (and gauging the size of the trees in the background), one could accurately guess that this fruit would have come from their own grove. During the war, fruit stands had become one way for the grove owner to attempt to sell his produce; this was due to the near extinction of bulk shipping owing to wartime shipping demands.

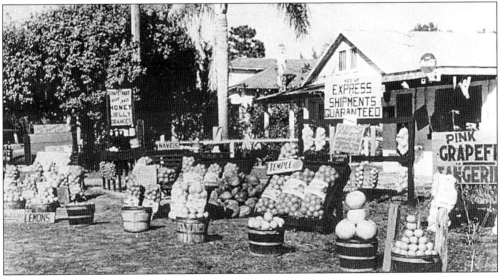

In 1945, Charley and Winona Jones opened this roadside fruit stand—shown in this 1952 photo—located on Alt. 19 and Virginia Avenue in Palm Harbor. They operated it until 1960, after a freeze in 1957 killed their grove and seriously damaged or killed many others. In 1960, they sold the property to a person wanting to open a stand to sell fresh vegetables and fruit.

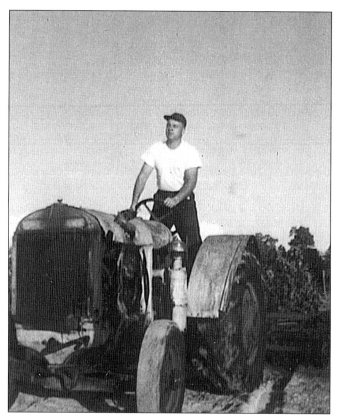

This photo (taken around 1955) shows Charley Jones working an old McCormick Deering tractor, which had been used for many years in his uncle Russell Jones's Grove Caretaking business. After a full day's work in his construction business, he would work the grove in the evening. His children still love to talk about the "fire" that seemed to come out of the exhaust as he worked.

A later photo, taken in July 1957, shows more afternoon work in the now almost-mature grove. Notice the size of the citrus trees. This particular section of Valencia-orange–laden trees would be ready to pick for the first paying season in February 1958, after four to five years of growth and care.

Disaster struck on Saturday, December 18, 1957, with warnings of an expected freeze. Growers had prepared their groves, laying out the wood for "firing" (which used smoke, more than heat, to attempt to keep the cold from settling). Remnants of the wood placement can be seen in this photo taken a few weeks after the freeze. This entire grove was lost when the temperature went to 18 degrees before 10:00 p.m., stayed below 28 degrees—the critical point—until well into the following day, and froze again that Sunday night.

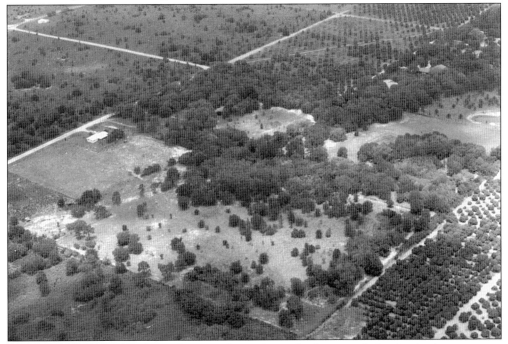

This aerial photograph, taken a few years later, shows the house and clearing in the center; to the left is the location of the former grove. County Road 1 is the only paved road in the far upper left. That entire portion of the photo had been bearing citrus groves. Remnants of other groves can be seen, especially in the lower right; that area is now Piper's Meadow Subdivision.

53

Beef cattle replaced some of the former citrus land, and provided meat for the family or to sell to commercial outlets. This particular trio was part of a larger herd that enjoyed the lush grass from the grove destroyed in the 1957 freeze. They were seeking shade from the midday summer heat.

This mother and calf were from prepared pastureland that was not suitable for citrus; thus, this land had always been pasture. The trees in the background reveal that this was wetter land without the natural drainage that citrus groves required.

Three

FARMING AND FISHING

Eugene Hill seems to be enjoying his private hay ride in the Sutherland area in 1917 as he drives the team with a fresh load of hay for the horses and cows. This photo is an excellent example of how hay was cut, loaded on the wagon, and taken directly to the farm animals (or the barn) before baling machines came into use.

From the earliest settlers, people—including the Boyds, Jacksons, Caseys, Dixons, Sauls, and Boyettes —"ran" cattle in East Lake. Before a state-wide fence law was enacted in 1950, at least two cattle roundups were held each year. The author remembers her father, uncle, and brother loading their horses to help gather and brand cattle in the 1930s and 1940s. Once the fence law was in place, people were required to secure their cattle. Jesse Boyd, an early cattle and citrus grower, kept his cattle in the area east of Lake Tarpon and citrus groves on both sides of Curlew Road, east of today's U.S. 19. He and Judge Thomas Hartley were very good friends; thus, Jesse was allowed to use the Hartley telephone when he was at the grove or ranch. In return, when the power company wished to run high voltage lines through the Hartley grove, Jesse arranged for electricity to be run through the Hartley home. Jesse's oldest son, Alfred, loved the cattle business and, upon his discharge from service after World War II, became intimately involved in the business. This eventually led to the establishment of Boot Ranch, whose name came from a mammoth boot that Alfred constructed and placed at the ranch's opening. The decal shows that it was considered Palm Harbor at that time. As Alfred Boyd became more involved with the business, the ranch was enlarged to include a majority of East Lake. Alfred followed his father's work ethic, devoting much time to improving his herd and, through scientific investigation, to creating new breeds adaptable to this and other areas around the world. Due to Alfred's endeavors, these special cattle were shipped worldwide from the St. Petersburg/ Clearwater Airport for many years; in fact, that was a primary reason for the airport's beginning.

Lee Nigels is proud of his 900-pound Hereford bull, which he is preparing for the upcoming Pinellas County Fair in 1954. He often won one or more ribbons for his cattle; however, he enjoyed the keeping and caring for the animals more than the recognition of the awards.

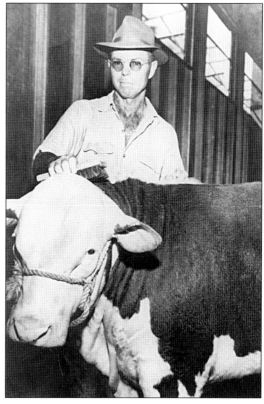

Lewis Beckton raised these ducks on his farm along with chickens, but no turkeys (according to his daughter). He believed one could raise anything in Florida soil and set about doing it. For some time, his family only bought coffee, flour, sugar, and salt from the grocery. Everything else the family required, he raised and Mrs. Beckton either knew—or learned—how to cook, preserve, or can it. When he became tired of paying the feed bills for his livestock, he began growing Egyptian wheat, rye, oats, and corn; the corn grew under his care to be 17.5 inches tall.

Ray Meyer and Benjamin Franklin Meyer (Ray's father) enjoy an afternoon fishing from their dock on Lake Tarpon. Even then, this was a very relaxing way to sit and enjoy leisure time together, and perhaps, a treat of either a bass or perch dinner could be gained from the effort.

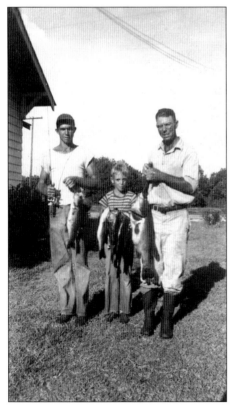

Although these three residents lived on County Road 1, they would often visit Lake Tarpon as grove work permitted. Pictured is the result of one such trip: a nice catch of freshwater bass.

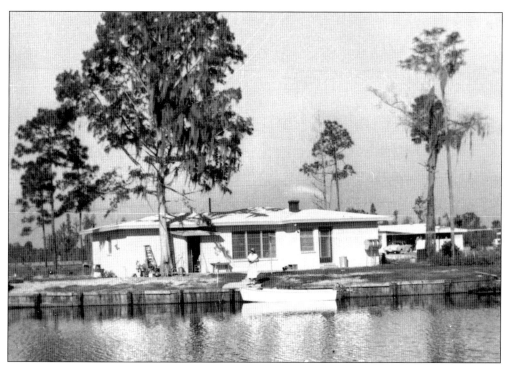

A late 1940s scene shows the new development called Lake Tarpon Estates. This house on East Canal Drive was newly completed. Other undeveloped land is clearly visible, as are the wooden sea walls, rather than today's cement walls.

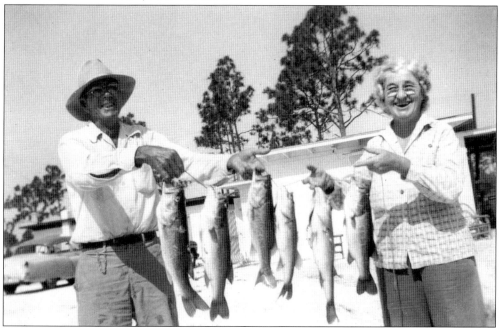

These two home owners in Lake Tarpon Estates, Ray and Ruth Meyer, spent many happy times catching bass either from their dock or from a short trip into the main lake. The catch pictured occurred in June 1953.

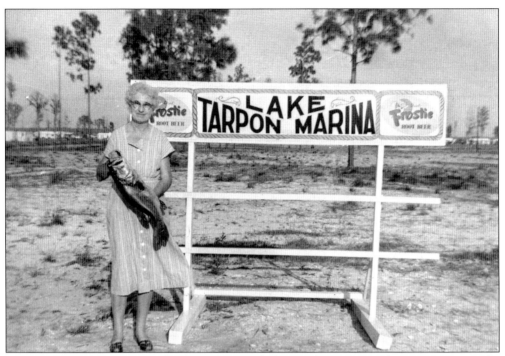

Mrs. Ray (Ruth) Meyer proudly shows her catch from Lake Tarpon. The marina was under construction when this photo was taken in the early 1960s. The lake was becoming more well-known as the "Bass Capital of the World," thanks to pictures similar to this.

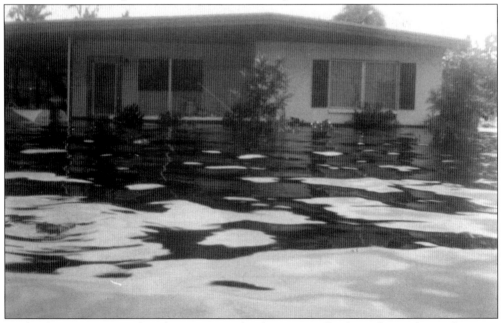

As development increased in the area around Lake Tarpon, flooding of some homes began to be a problem. The home in this photo became a victim of one such disaster. As a result, the Lake Tarpon Outfall Canal was created; this has corrected the flooding problems and created another fishing location.

Whenever fish were caught, they also had to be cleaned. In this photo, Sherman Opp tends to that job at his 1950 fish camp on another lake in the region.

This proud young lady, Sharon Jones (invited with her family as guests to a freshwater fish camp), had the good fortune to catch her very first fish. As much as each of these freshwater fishing pictures reveal the pleasure and food obtained from the lakes and rivers, early settlers and modern-day residents also realize the joy and pleasure of saltwater fishing.

This oyster house, built at the northern part of Tampa Bay, provided shelter for overnight and weekend trips. The owner (and usually at least one other person) would carefully plan their trips according to tides and, often, the availability of ice—if they planned on shucking the oysters there.

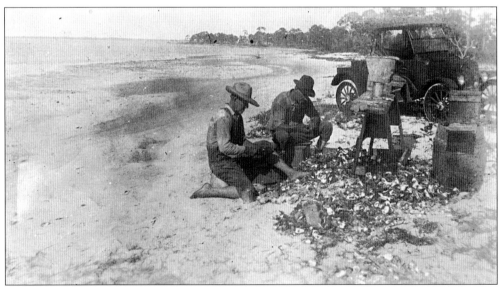

These two men, one of whom was the owner of the "house" above, are shown shucking the oysters they have gathered during low tide from the oyster beds in deeper water. Visible both on the truck and by the bench are the drum-like containers that would be filled with ice. As a young child, the author recalls spending many happy days at this location, eating more raw oysters than anything else. Unfortunately, they are no longer available in this particular spot because of pollution.

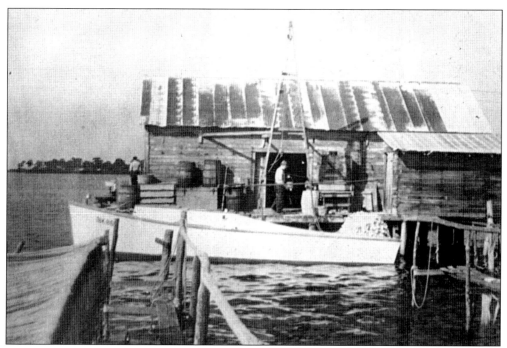

An Ozona commercial mackerel boat is netted and ready to go out. The pulley, which is visible on the dock, will be used to lift baskets of fish up to the loading dock on the boat's return. John Garret works near the door of the fish house, which was (at this time) owned by Paul and Donna Fair. (Courtesy of OVIS.)

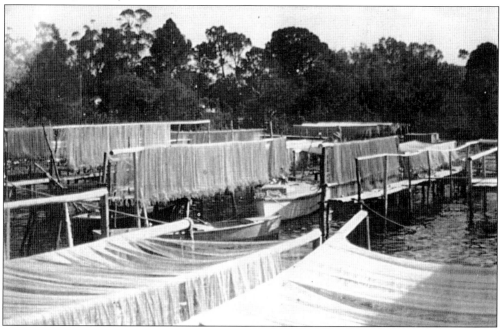

An array of fish nets dry on net-spreads at the Ozona fish house. As they dry, the owner (or a hired hand) will also mend the nets; mending work is done with a very specialized needle, which most fisherman are taught to use in their childhood. (Courtesy of OVIS.)

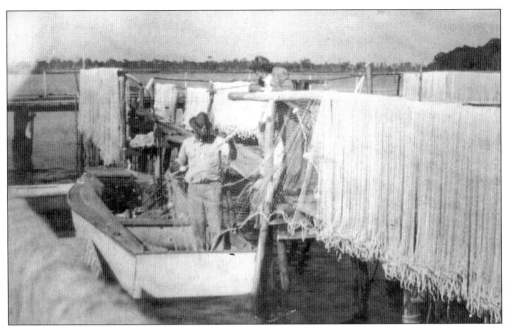

Tony Masce of Ozona stands in a small launch he built after returning from World War II, where he served with the U.S. Navy Seabees. In this photo, he is netting a boat for another commercial boating trip, while a friend (Mrs. Samples) observes. (Courtesy of OVIS.)

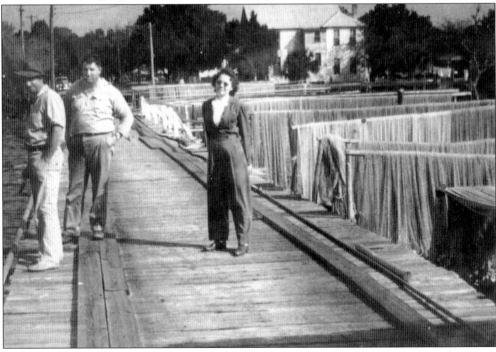

Tony Masce appears on the Ozona dock with his visiting friends, Mr. and Mrs. Samples. Tony and Mr. Samples served together in Guam during World War II. Notice the boards fastened on the dock; these were needed to support heavy truckloads of fish being sent to market. (Courtesy of OVIS.)

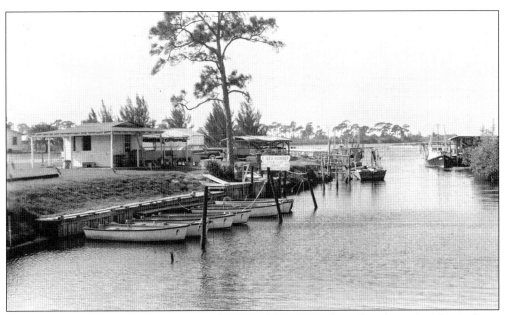

The Ozona Sea Horse Fish Camp allowed private fisherman to launch or keep their boats there. The creek was originally named Craver for J.C. Craver, a pioneer of both Ozona and Palm Harbor; its name was changed to Minnow Creek many years later. In the camp's earlier days, it was known as the Saunders Camp for the family who began the fish camp.

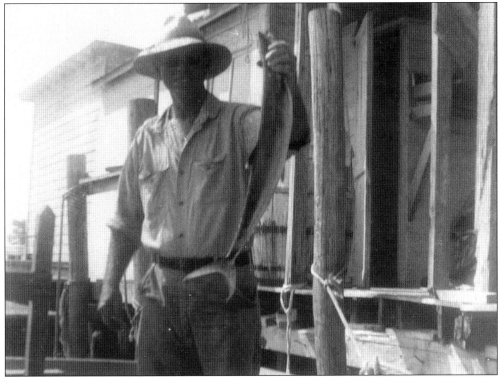

An unidentified fisherman appears proud of the fish he caught on his saltwater trip. This entire area is fortunate to have so many excellent locations to enjoy both fresh- and saltwater activities.

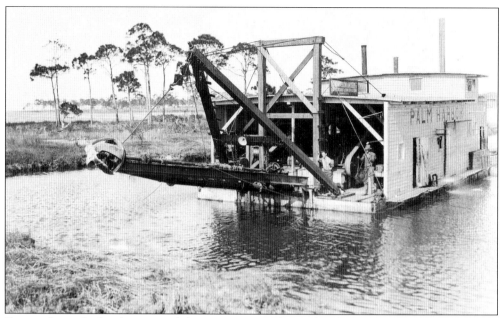

During the early development of the pristine waterfront, this dredge was beginning to fill in land along the 1888 plat line. At some point in this work, it was discovered that a large portion of the Sutherland Bayou was underlain by solid rock. This prevented much of the work from completion as the early developers had envisioned. The Crackers have always been aware that you need to know your tides and the waterways to use that area. Any boat larger than a dinghy would anchor far out in the bay, even before the Intercoastal Waterway was created, and use a dinghy to bring their product to land.

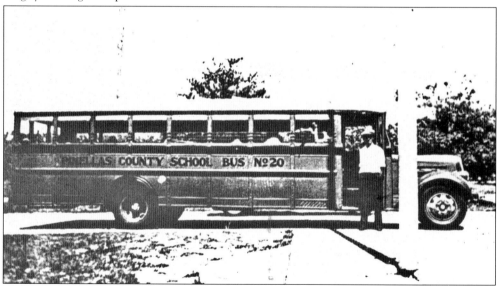

Gray Rogers was the bus driver for the mid-1930s White school bus. The White Manufacturing Company produced many of the buses used during that time. The pictured bus was of particular interest, as it was one of the earliest to have only a front and rear door. Prior to that time, each row had its own door; the driver (or a monitor) would have been the one to open and close the door.

Four

CHURCHES AND SCHOOLS

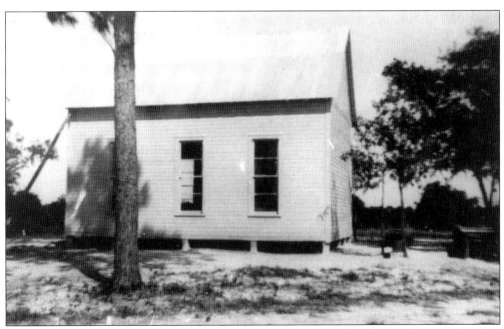

In 1886, this wooden church was constructed on the five acres of land on 16th Street that had been donated by A.P.K. Safford. Originally, the church had wooden window shutters, which were propped open for services; glass windows were installed many years later at an unknown date. The building no longer exists, but the cemetery (planned for the remaining land) does. Descendants of those early families hold regular clean-up days to keep the cemetery tidy.

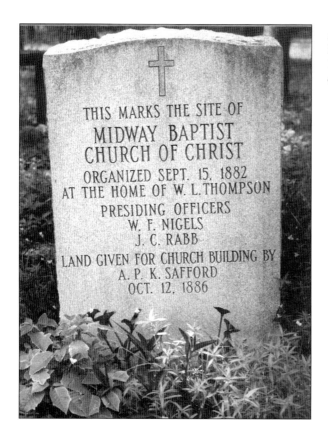

As noted on this memorial, the Midway Church was organized in 1882, making it the second official church "around Palm Harbor."

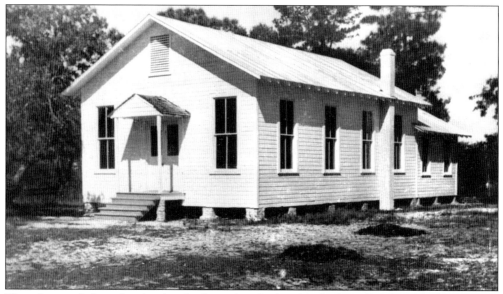

This photo is believed to be the third wooden Curlew Methodist Church, with the first two destroyed by fire. John Alexander Sutton, an early settler, donated the land for a church and cemetery—provided he could name the church. Sutton believed that the bountiful pink birds along the nearby creek and land were the most beautiful of the area, and he was told that they were Curlews. Thus, the name Curlew was given to both the church and the surrounding land.

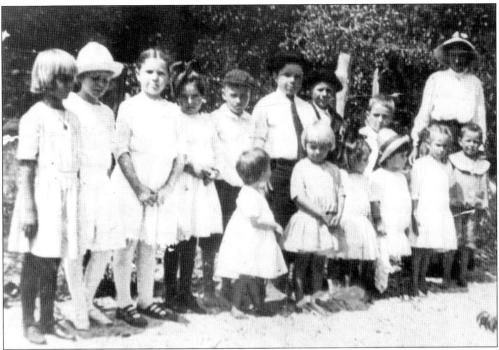

A Curlew Church Sunday school group gathers for a photo. The only ones identified are (front row) Dora Sutton (wearing the hat) and James Johnson (far right end of row); (back row) Mary Sutton (third from left), Clarence Sutton (sixth from left), and the teacher, Mrs. Sarah (Sally) Robinson Jones. The provider of this photo believed that it was taken on an Easter Sunday sometime in the 1920s. Notice that several of the younger children are barefoot.

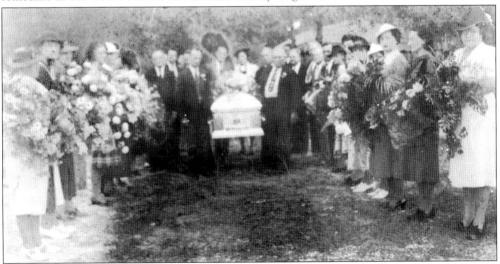

This photo illustrates some traditions of funerals in the past. This funeral was for Mrs. Sarah (Sally) Robinson Jones in 1935 and was held at the Curlew Church and Cemetery. The ladies involved in the service may have ordered the flowers from a florist; however, it was not uncommon for people to create their own designs. One of the traditions that existed before this date was (at least for a highly revered person) that the mourners would actually line the interior sides of the grave with flowers before the funeral.

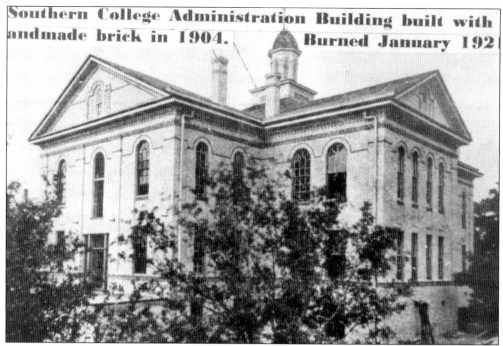

Southern College Administration Building built with handmade brick in 1904. Burned January 192[]

This handmade brick building, built in 1904, was usually just called the Administration Building of the Southern College when it was located in Sutherland. However, it also contained a chapel on the top story, which would seat 750 people. That was the original First Methodist Church of Sutherland; however, this building burned in 1921.

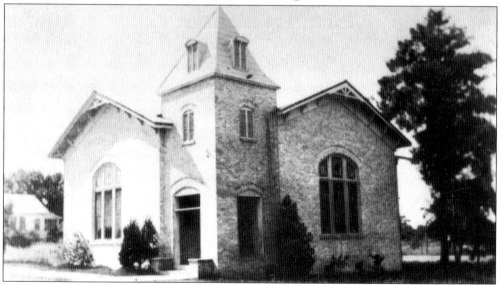

Now known as White Chapel, this church, created in 1924 from the brick saved and cleaned by the people of the entire community (regardless of denomination or place of residence), is located at the southwest corner of Georgia Avenue and 12th Street. Each of the church's walls is four bricks thick. The bell from the Administration Building was placed in the tower of this church; it is still rung at appropriate times. The stained-glass windows were bought by individuals and remain today with the purchaser's name still visible.

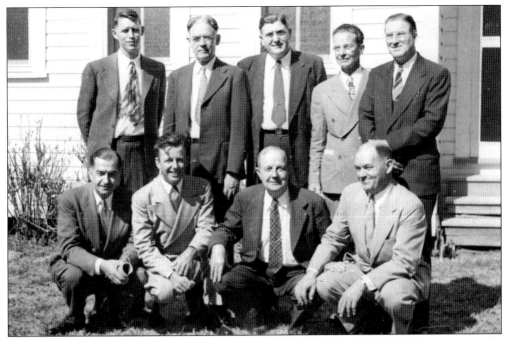

The Ozona Baptist Church was host to the Pinellas Ministerial Baptist Association in the wooden church in the early 1940s. The host pastor, Rev. Allen Young, stands at far right in the back row. Kneeling in the front row (second from left) is S.J. Henderson, lay minister and a leader of the Ozona Church.

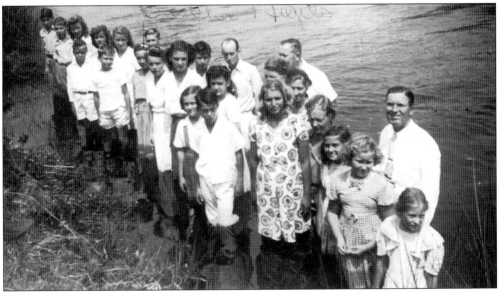

After a revival at the Ozona Baptist Church in the mid-1940s, this group waits to be baptized in Ozona's Minnow Creek on a Sunday afternoon. Rev. Allen Young is at far right in the back. Although some of these new members had been members of other denominations, under Baptist doctrine they, too, had to be immersed to become members of the Baptist Church. The Ozona Church did not have a baptistery at that time, hence the necessity of going to a body of water for the ceremony.

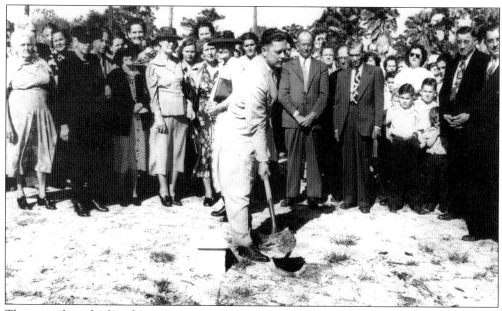

The ground was broken for a new sanctuary for the Ozona Baptist Church in the late 1940s. In this photo, Earnest Walker has the honor of the first shovelful of dirt. There are far too many participants to be identified in this publication; however, members of many prominent families are recognizable, including "Pop" Stansell and members of the Ulmer, Sutton, Jones, and Thompson families. The Reverend Matheney can be seen on the far right.

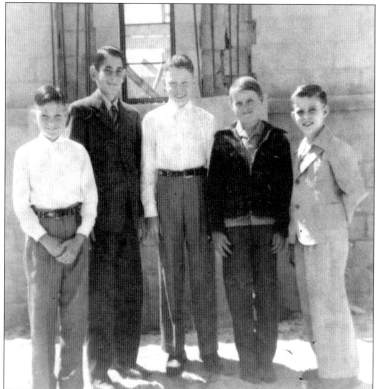

Members of a Sunday school class of the Ozona Baptist Church check out where their future class may be held when the new building is completed. Pictured are, from left to right, unidentified, Eddie Crow, Oliver McEacheron, Darryl McEacheron, and Gene Ulmer.

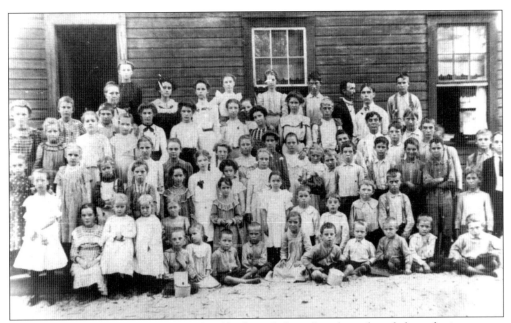

Built in 1890, the original Curlew School had pupils from first through eighth grades in a green-painted wooden building situated on School House Road—now West Lake, south of Tampa Road. The young people in this early 1900s photo would have lived in the Curlew and eastern Palm Harbor area; the only other local schools were in Ozona and Wall Springs.

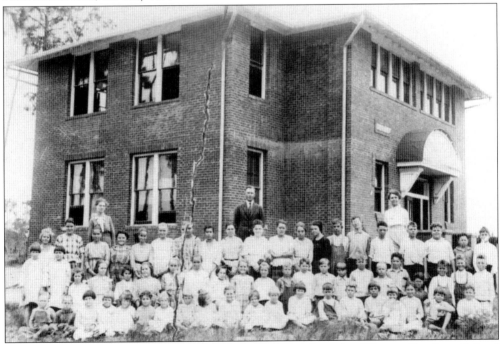

This red brick Curlew School, built in 1916, was located north of Tampa Road, on School House (County Road 39 or West Lake Road; all three names are still used by different people who live in the area). Grades one through eight were taught by the principal, Mr. Curlin, and two teachers, Mrs. Curlin and Ms. Katherine Plum.

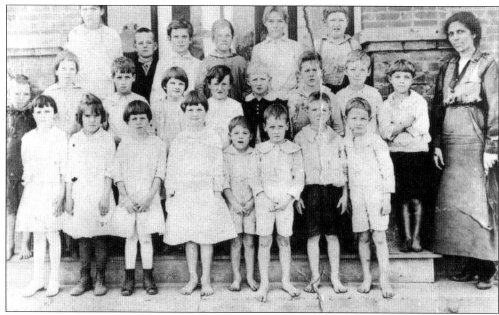

Curlew School first- and second-grade students pose in 1918 with their teacher, Miss Wells. Included in the photo are Eula Lee Johnson, Willie Grace Johnson, Annie Lee Sutton, and Eston Thompson. Notice that most of the children are barefoot; at this time it would probably have been by choice.

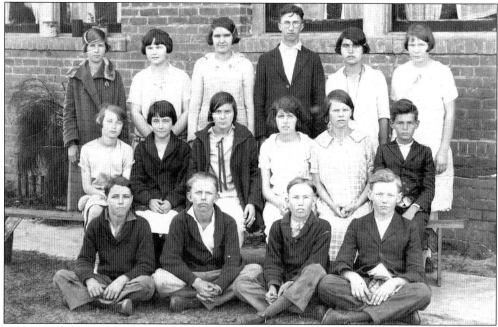

This photo of the seventh and eighth grades of the Curlew School in the 1920s includes, from left to right, the following: (front row) R.L. Fletcher, Harlan Anderson, unidentified, and Ronald Swartzel; (middle row) Helen Shelton, Lonice Fletcher, Ruby Baxter, Willie Grace Johnson, and ? Shelton; (back row) Louise Beckton, Verdie Sutton, Christine Riviere, Roger Johnson, unidentified, and Louise Layfield.

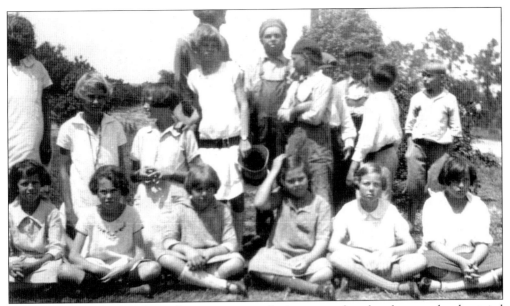

This 1920s class chose to have their picture outside; it appears that the photographer has tried to arrange them just so. Included on the front row are Ila Kersey, Jewel Hunter, Connerlia Hendrix, Wetoka Sutton, Rheu Swartzel, and Dorothy Albury; the back row includes Eva Moore, Ida Pope, Dosie Griffin, Myrtice Nutt, Irvin Ennis, Johnny Mueller, and Rufus Baxter.

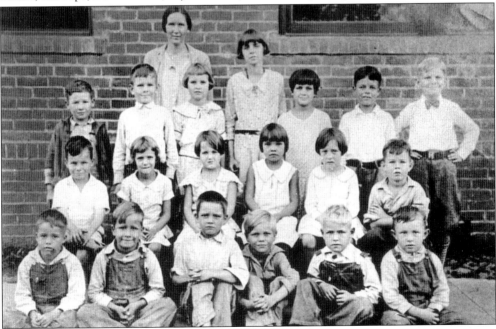

This photo of the first and second grades of the Curlew School was taken in 1931. From left to right are (front row) Ellis Lipsey, Hampton Stevens, Charles A. Jones, George Baxter, Howard Hagin, and Mac Hart; (middle row) Glen Marchant, Millie Parker Usher, Essie Mae Williams, Annie Hurst, Myrtle Cribb, and Phillip Sutton; (back row) Samuel Elmon Hart, Edgar Sutton, Louise James, Ruby Mueller, unidentified, Hillburn Henderson, Paul Whetstone Jr., and Miss Eloise Thompson (the teacher). This photo was taken during the worst of the Depression.

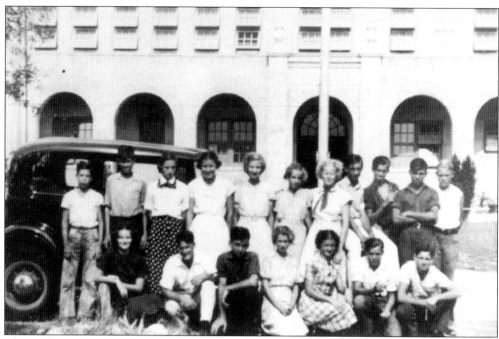

The students in this photo comprise the 1938 graduating class of Palm Harbor Junior High School. Originally built in 1926, the school was rebuilt after it burned in 1949; eventually, it became an elementary school. Some of the students are Howard Stull, Russell Burns, Doyle Daniels, Enid Fulford, Trudie Noxtine, Gene Walters, Carson Sapp, and Arnold Green.

COMMENCEMENT

PALM HARBOR JUNIOR HIGH SCHOOL

JUNE 2, 1939

Invocation	Rev. Hodnett
Welcome	Bettie Moody
Class Historian	Louise James
Accordian Solo	Rheba Ulmer
Class Phrophecy	Ford Moody
John Solo	Peggy Ericson
Class Will	Bill Wood
Presentation of Diplomas	H. P. Delamater
Benediction	Rev. Hodnett

GRADUATING MEMBERS

Cashwell Gause	Bettie Moody
Vernella Grissett	Ford Moody
Hilburn Henderson	Mary Norman
Louise James	Olin Owens
Charles Jones	Philip Van Valkenburg
Robert Jones	Bill Wood

In Pinellas County, and throughout most of Florida, the school grades were arranged differently then than they are now. Grades 9 through 12 were considered high school; however, the ninth grade was housed in the junior high building. In Pinellas County, the fifth and sixth grades were also housed in the junior high building, although they were considered elementary students. Due to this arrangement, most ninth grades in the area had a very formal graduation ceremony. This commencement program is from the Palm Harbor Junior High School graduation on June 2, 1939.

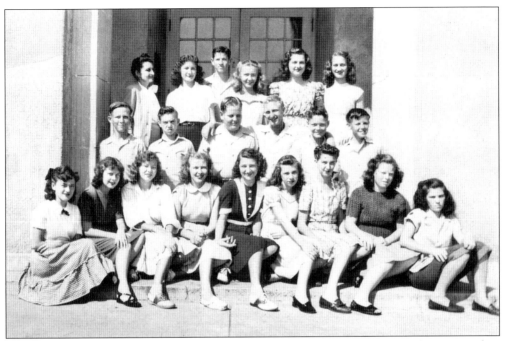

Members of the Palm Harbor Junior High ninth-grade class were photographed in 1947. They are, from left to right, as follows: (front row) Betty Stansell, Louise Godwin, Jackie Tinney, Dorothy Ammons, unidentified, Marlene Pullian, Maybelle Creamer, and Clara Jean Thomas; (middle row) Herbert Mann Jr., Wylie Orr, Robert Crow, Earl Caraway, Philip Thompson, and Dick Gerock; (back row) Mrs. McArthur (teacher), unidentified, Harvey McDaniel, Donna MacAllister, June Ammons, and Louise Williams.

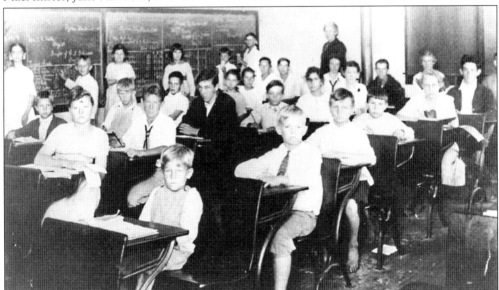

The original wooden Ozona Elementary School opened in 1895. It was located west of the brick school building that is still used today. When the new building was erected and opened in 1916, the old wooden school was purchased and turned into apartments. This photo of students from first through eighth grades was taken the same year the new school building opened.

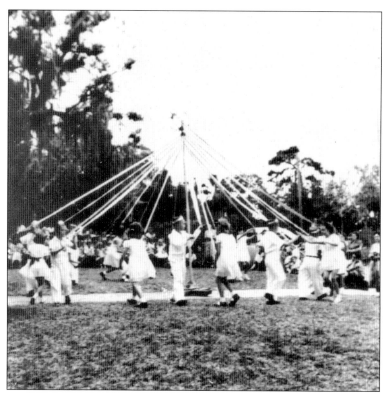

May Day was celebrated in most county elementary schools from the mid-1930s through the 1950s. Each grade would prepare and present a particular part of the program. This May Pole Dance, at Ozona Elementary in 1947, was performed by the fourth graders.

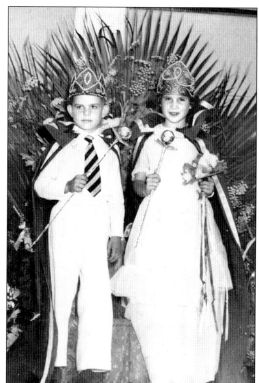

Each school also chose a King and Queen of May in their own particular manner. These two honorees at Ozona in the early 1950s were Donald Walker (king) and Patricia Hogue (queen).

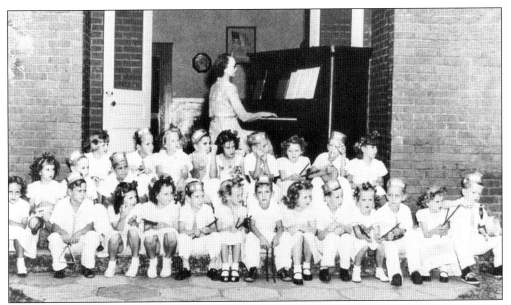

By 1940, Daisy E. Riviere was a teacher and principal of the Ozona Elementary School. Her father, Fred Ericson, had helped build the school, and Daisy received her elementary schooling there. In this photo, the school piano had been temporarily moved from her classroom to the front doorway in order to accompany the third- and fourth-grade rhythm band during the annual May Day Program in 1940.

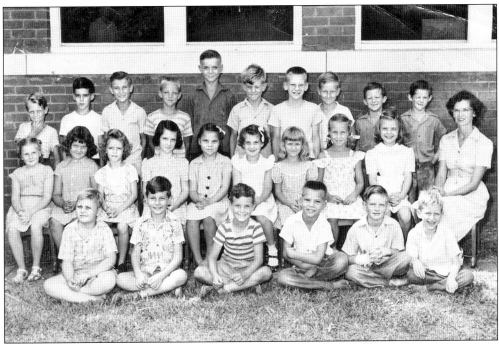

This photograph features the 1947–1948 second-grade class from Ozona Elementary School with their teacher, Miss Rathgader. By this date, the growth of the community was reflected in the addition of many new students at the school each year.

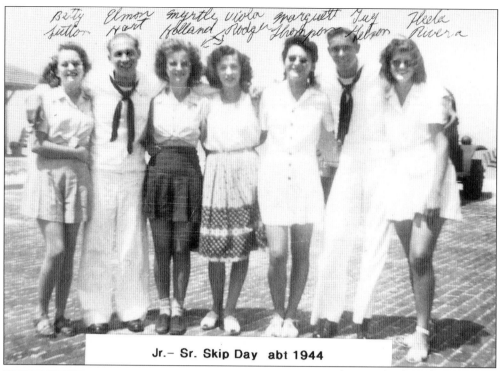

Betty Sutton, Elmon Hart, Myrtle Holland, Viola Rodger, Marquett Thompson, Guy Gibson, Fleeta Rivera

Jr.– Sr. Skip Day abt 1944

A senior high tradition had long been Junior-Senior Skip Day. These Tarpon High School young ladies had taken advantage of that tradition to see two members of the navy who were home on leave. Everyone in this photo had grown up in the area and had been classmates since their early years; they are, from left to right, Betty Sutton, Elmon Hart, Viola Rogers, Myrtle Holland, Margaret Thompson, Guy Gibson, and Fleda Riviere.

College days also had their lighter moments. Here, some unidentified young people give us a look at the beach wear in 1917. Most ladies did not actually swim, but rather bathed and sunned (much like modern beachgoers)— even though they carried their ever-present parasols.

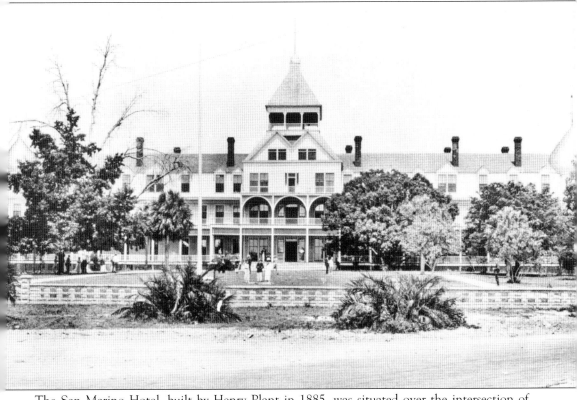

The San Marino Hotel, built by Henry Plant in 1885, was situated over the intersection of Florida Avenue and Omaha Street in the Palm Harbor Historical District. The original hotel burned in 1886 and was rebuilt, as shown in this photo. It continued as a hotel until 1902, when the Florida Methodist Conference accepted a bid from the Southern Land Development Company to purchase both hotels on Florida Avenue. Thomas Hartley had attended the conference as a devout layman in the Methodist Church in the early 1890s, where it was approved to move their Florida Conference College out of Leesburg, Florida. When bids were called for, Hartley encouraged both the conference and the development company to consider the Sutherland location. The company submitted a bid that included not only the two hotels, but also 440 acres of land (valued at $2,000) and an additional $5,000 in cash. This bid was accepted; the college was moved to Sutherland and renamed the Florida Seminary. The hotel became the women's dorm, administrative offices, and housing, as well as the college kitchen and dining area. The two 280-foot verandas made excellent social areas. The road in the foreground is Omaha Circle.

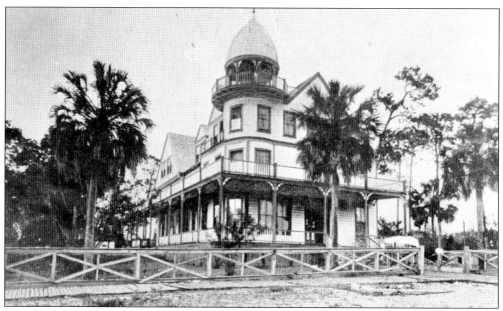

The Gulf View Hotel, which was situated at the northeast corner of Florida Avenue and the Dixie Highway, became the men's dorm in 1902. This entrance, facing Florida Avenue, clearly shows the wooden sidewalks on the north side of that thoroughfare.

These two new buildings were added to the campus of Southern College in 1911: the one on the left was a new men's dorm, while the one in the forefront was the gymnasium. The two buildings survived for a number of years. The author remembers playing many volleyball and basketball games as a junior high student in the early 1940s in that gym.

Your presence is requested
at the
Tenth Anniversary
of the
Eroletheian Literary Society
Saturday evening, February the third
nineteen hundred and twelve
at seven o'clock
Southern College Auditorium
Sutherland, Florida

Fleda Hope, a student at Southern College, sent this invitation to the Tarpon Springs Levin Vinson family. The Eroletheian Literary Society had been organized on October 10, 1902. It was recognized as one of the most notable organizations of the college, and it was a great honor to be a member or to receive an invitation to join the society. Miss Hope later married the son of the recipients of this letter. He began the Vinson Funeral Home, which remains a respected business in the Tarpon Springs area. They have numerous descendants who remain very active in the northern Pinellas communities. Of special interest here is the Sutherland postmark and the price of the first-class stamp. (Courtesy of Bill and Barbara Vinson.)

This photo of the 1912 Southern College graduating class and their families was recently donated to the local museum. The female graduates all wear white dresses, while the male graduates are dressed in suits. Apparently, this photograph was taken on either the back steps

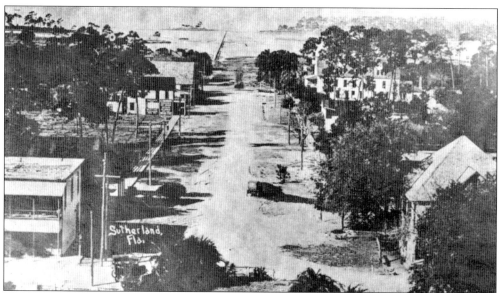

This view of Florida Avenue in Sutherland c. 1910 was taken from the cupola of the San Marino Hotel (Southern College). On the top right, the first boy's dorm is visible. The two buildings along the bottom of the photo are the Durrance Building (today's Oak Trail Book Store) and, on the left, the Hill Building (today's Geographic Solutions). In the top center of the photo, the wooden bridge to Pig Island can be seen.

or the side steps, as opposed to the main front stairs. Nonetheless, the photo does afford a somewhat close-up view of the porch that nearly surrounded the building.

The boardwalk over the shallow water of Bay St. Joseph connected the west end of Florida Avenue with Pig Island. Sarah (Thompson) Mann loved to relate how, as a student, she was part of the group of young people (and their chaperones) who were given permission to picnic on the island. Very unexpectedly, the bridge collapsed half-way across. The young men quickly rescued the young ladies—stealing a kiss or two in the process. Being the gentlemen that they were, they then returned to bring the chaperones safely to shore.

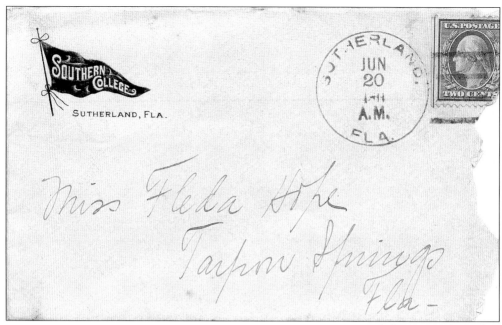

Fleda Hope, who had graduated from Sutherland's Southern College, sent a wedding announcement to a former instructor; she saved the answer she received, shown here and opposite. It served as a reminder of the personal contact, which was a very important part of the higher educational experience. (Courtesy of Gene and Barbara Vinson.)

My dear Fleda :-
 Just a short note tonight to let you know that I have not forgotten you and yours.
 You cannot begin to imagine how I hated to miss all the nice things given for you and am we all I

cannot go to the Wedding. I am so
sorry, but I just cannot help it.
My feet are worse tonight. I had
hoped so much to be able to go.
But you will have to tell me
all about it when I see you
again.

Dear Girl you are entering another
sphere of life. They say the
"Happiest". And I do wish for
you every joy, and may you
have every heart's desire. "Der" is
surely to be congratulated in
winning such a grand girl. We
rejoice with him.

Mama said tell you she intended
writing tonight but is too sick
and tired.

She joins me with every
good wish for you all.
And may your life be
a most happy one
Much love to both of you

Devotedly
Edna —
"Southern"
June, 19 - 1911.

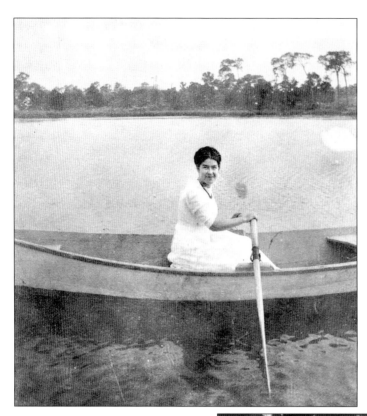

Fleda Hope (Vinson) was born in Tarpon Springs and, as aforementioned, graduated from Southern College in Sutherland (Palm Harbor) in 1907. This picture was taken on the Ancolote River, where the Vinson family continues to own property on the north side of the river. The very early Meyer family also had homesteaded property in the same area. (Courtesy of Gene and Barbara Vinson.)

Lake Tarpon appears very tranquil in this view from 1949. Through the years, the large freshwater lake has been as much a place to spend some quiet, meditative time as for boating or fishing; one needs to be cautious, however, when a storm cloud can be seen approaching. Although the quiet times are (unfortunately) becoming harder to find, views such as this will hopefully continue to inspire feelings of tranquility.

Five

OUR SERVICE
PERSONNEL

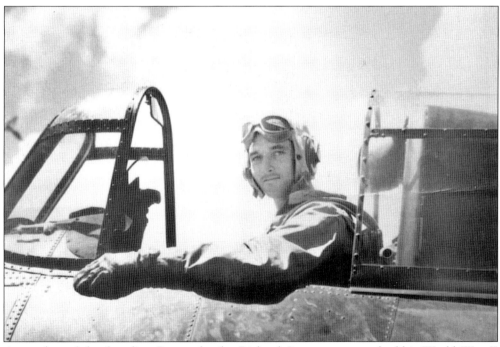

A member of the founding Sutton family, Richard Sutton was proud of his World War II service; he is seen here in his navy fighter airplane. He and his wife, Rheba Ulmer Sutton, were charter members of the historical society and were active as long as their health allowed. Although they are both deceased, their knowledge of and love for this area will always remain.

World War I
United States Army
Charles Hagan
Charles L. Jones
Ray Meyer

World War II

United States Army
William F. Allison
Carl Childs (later Air Force)
James D. Christmas
Charlie Dixon
Paul Fair
Herman Gerock
Arnold Green
Ralph Green (later Korea)
Mirian Guthrie
Leland Jones
John D. Lindsey, I
D.S. Lovett*
Howard T. Pearce (later Korea)
Donald Reeves
Carl Maurice Robinson
Adrian (Ace) Thomas
Kenneth Tinny
Hugh M. Ulmer
Ray E. Ulmer

United States Marines
Paul Hamilton *

United States Navy
Horace Bolger
Thomas Christmas
Doyle Daniels
Ernest Emanuel
Henry Emanuel
Luther Emanuel
George R. Gause
Cecil Gerock
Samuel Hart, Sr.
Mack Hart
Clarence Jones
James Jones

Ellis Lipsey
Vernon L. McCook
Melvin Masce
Tony Masce
Donald Meyer*
Richard Sutton
Eugene Thomas
Marvin Thomas
William Tinny
Lewis Wood
William D. Wood, III
Phillip Zimmerman

United States Coast Guard

Guy Gibson
Herman Gibson
Richard Zimmerman

United States Air Force
Donald Tinny
Melton Tinny
Dwain Wood

Those who served their country at other times
Ralph Emanuel
Randy Emanuel
Robert Garrison
Gerold Gerock
Jack Hogue
Robert E. Jones
Robert Brian Kersey
Robert D. Lungren

*Killed in Action

There were many from this area who served in our nation's armed services from World War I through the Korean War. Efforts are under way to establish as complete a listing as possible, now including the Vietnam War and the war in Iraq and even going back to the Civil and Mexican Wars.

Albert Ray Meyer, seen here in his World War I uniform, was on his way to France when he had this picture taken. He was the son of Mr. and Mrs. Benjamin Franklin Meyer, who lived on Lemon Street in Ozona when they received this postcard.

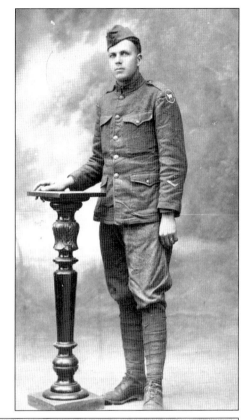

Charles Leland Jones sent this postcard during World War I, after his arrival at Camp Jackson, South Carolina, to his mother, Mrs. John Courts Jones, who lived in Sutherland, Florida. During the army's drive through France and Germany, Jones was gassed and very severely wounded. Although his family was notified that he had been killed, he recovered and returned home to marry his sweetheart, Blanche Meyer.

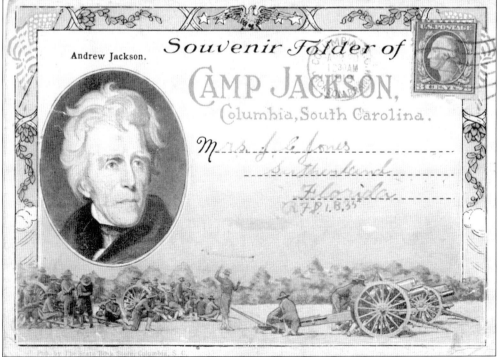

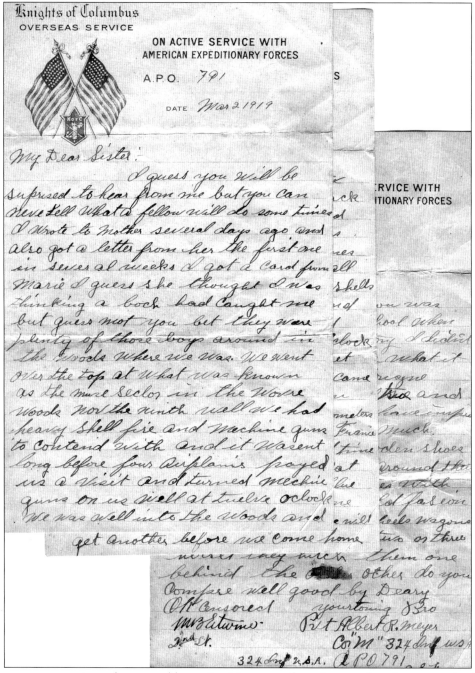

Knights of Columbus
OVERSEAS SERVICE

ON ACTIVE SERVICE WITH
AMERICAN EXPEDITIONARY FORCES

A.P.O. 791

DATE Mar 2 1919

My Dear Sister:

I guess you will be suprised to hear from me but you can never tell what a fellow will do some times I wrote to Mother several days ago and also got a letter from her the first one in several weeks I got a card from Marie I guess she thought I was thinking a boch had caught me but guess not you bet they were plenty of those boys around in the woods where we was. We went over the top at what was known as the mure seclor in the Woure woods nov the ninth well we had heavy shell fire and machine guns to contend with and it wasent long before four airplains payed us a visit and turned mechine guns on us well at twelve oclock we was well into the woods and get another before we come home

behind the ⬛ other do you compare well good by Deary

OK censored your loving Bro
Wm Ething· Pvt Albert R. Meyer
2nd Lt. Co "M" 324 Inf U.S.
 324 Inf U.S.A. APO 791

Here are two portions of a personal letter Ray Meyer sent from France, where he was serving in the army during World War I, to his younger sister Blanche, living in Ozona with her parents. The stationery is from a civilian organization, but one which was highly regarded—according to this soldier—by many service men. All personal mail was very carefully read before it could be mailed, seen here on the closing "sign off" as "OK censored." The entire letter speaks of this soldier's experience in a major battle and reveals his candid thoughts on the personal and military happenings. (Unfortunately, the letter was too long to be included here in its entirety.)

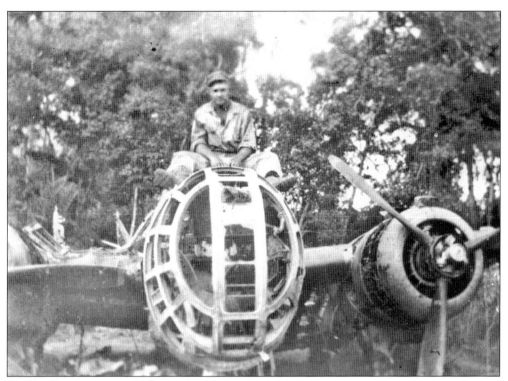

Charles Dixon grew up in the Sutherland and East Lake area and served in the Pacific Theater in World War II. He had been working on the plane seen here when a buddy asked to snap this picture. He recalls that he climbed up on the fuselage for this picture taken in the Philippines.

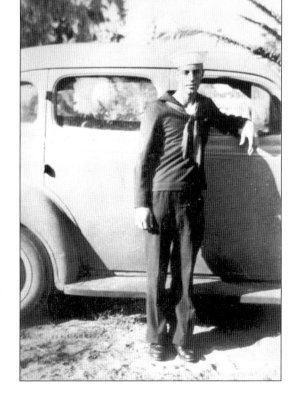

Robert Ernest Jones served as a fireman first class in the U.S. Merchant Marines during World War II (and afterwards). As the war progressed, the trips across the Atlantic became ever more dangerous; fortunately, near the end of the war, the submarine problem had been somewhat alleviated.

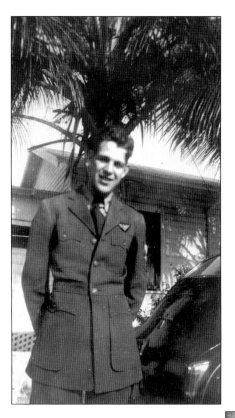

Donald Meyer, 23, served as a navy chief petty officer. He graduated from the Pensacola Flying School in July 1942 and flew considerable patrols in various war zones during World War II. He was killed when his patrol boat crashed at Key West.

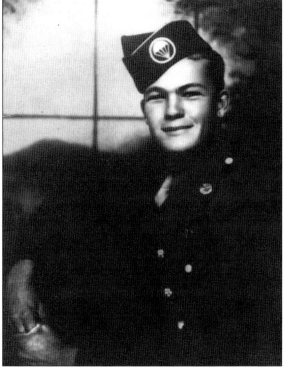

D.S. Lovett was extremely proud to become a member of the Parachute Corps in World War II. Since talk of war began, he spoke to his school buddies solely of doing just that; he did succeed, despite a handicap with his arm. Regrettably, he was killed in the war while performing his first jump during the European Invasion.

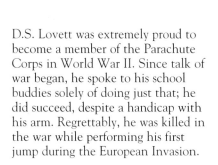

Six

AREA RECREATION

The Tea Room of Southern College in Sutherland was located slightly southeast of the female dorm (the San Marino Hotel). This was one location where the young men and ladies could talk with each other in their time off from studies. Of course, there were always chaperones present; however, the young people could make plans for future meetings. It seems that this is where students learned of the dates for upcoming "trunk socials" or picnics.

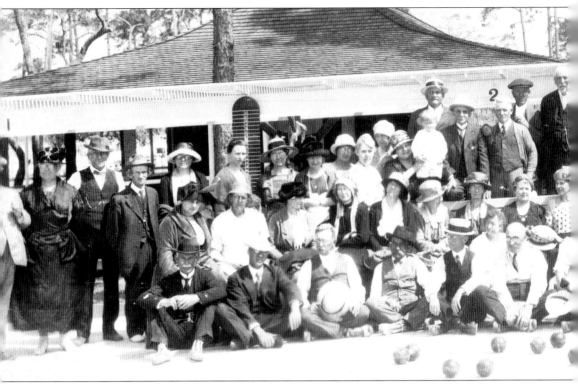

Although this photo is labeled Sutherland Lawn Bowling Club, it is believed to have been actually located in Ozona. Perhaps this is another illustration of how closely connected all these

Students at this tap and ballet dance class are being taught by Miss Enid Johnson (Fulford) (kneeling in front) of Ozona, who was about 17 years old herself; Enid's mother, Malvean, is at the piano. This particular 1940 lesson was held at the home of Enid's grandfather, J.D. Smith, on Grand Boulevard in Tarpon Springs.

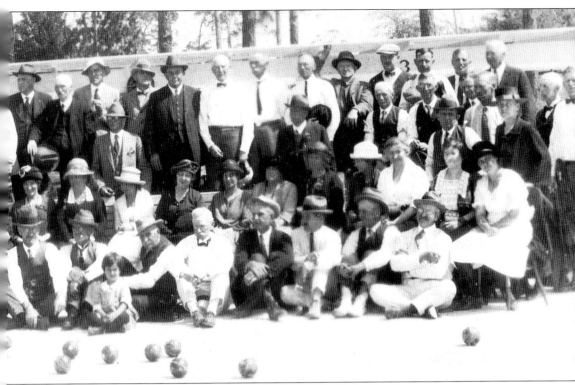

communities consider themselves, even to this day. (Courtesy of OVIS.)

Boy Scout Troop 26 is in the process of opening their meeting in this photo. The troop continues to exist and has a permanent scout hut on Georgia Avenue and 11th Street in the Historic District of Palm Harbor. It is, in fact, the longest continuing troop in Pinellas County. In earlier days, most young boys would have been members; many achieved high ranks but not always the coveted Eagle rank due to monetary and other restraints. Richard Sutton, an adult leader, is shown at right on the back row. Others in the photo are unidentified.

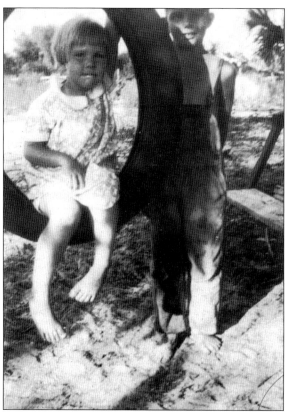

Two young people play with a tire swing, one type of swing that farm families enjoyed. Both of these children are barefoot; this was normal, not for monetary reasons but simply because that's how country children preferred it. The steps in the right center are on a fertilizer spreader that had been placed there temporarily. It made a perfect place to get a better swing by climbing up and then swinging out from there.

This board swing hung by large ropes from a limb in the oak tree. One fun activity consisted of winding the rope as tight as possible, then pushing as high as possible, so the rider would be swinging and unwinding simultaneously. The younger ones loved it (or so they said), but the adults knew to be around when the ride was nearly over. The three in this photo are getting ready for the pushing part of the swing; anticipation is visible in their faces.

These Ozona School students enjoy fresh-cut watermelon at their school. This may have been very close to the end of school or some other special, planned event. Watermelon days were always a fun time, even when clothes became stained, and the girls had fun spitting the seeds. Decorum was gone at such times: rich or poor, city or country, they were kids just having a good time together.

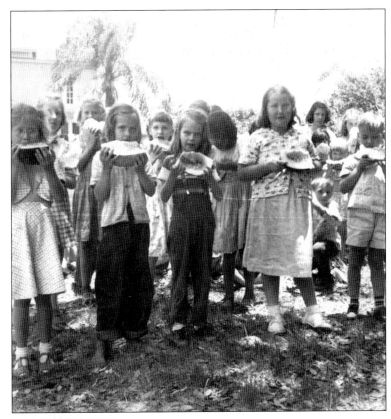

Fred Nigels grew these two huge watermelons on his property on County Road 1 in the early 1940s. This particular year was an excellent one for raising melons. Since these melons were extra large, Nigels wanted a picture taken to show that his efforts had paid off. The entire family ate as much watermelon as they wanted, and the cows enjoyed the remainder.

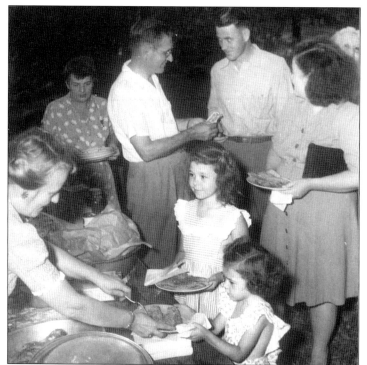

The Ozona Recreation Club Fish Fry was held in their park at the southwest corner of Bay Street and Banana Street. The children being served in this photo are Kitty and Patty Oakley, with their parents, Harold and Mary Oakley, standing behind them. Others in the picture are unidentified.

Some of Ozona's teenage boys enjoy one of many Ozona Recreation Club fish suppers in the early 1940s. Sometimes there were political rallies with candidates speaking. The menu was always very much the same: fried mullet, grits, baked beans, slaw, rolls, homemade pies, and coffee. Occasionally there might be grouper or other "fancy" fish, but most Crackers only wanted the mullet, which was very plentiful year-round with a cast net. Pictured from left to right are Homer Schaffer, Joe Paonessa, Leon Hart, Randy Emanuel, and Jerry Gerock.

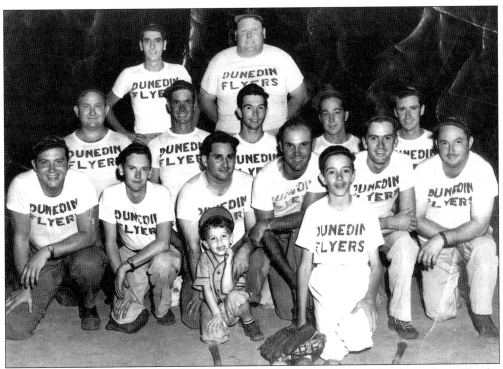

Although this team is named the "Dunedin Flyers," there are several local members. On the second row, second from left is Guy Gibson of Ozona; to his immediate right is Fred Nigels of Palm Harbor, and beside Fred is Bill Walters, also of Palm Harbor. Although there were teams in Palm Harbor, the young people tended to play for a team that included other people from the larger area; this was because they all had to go out of the area for high school.

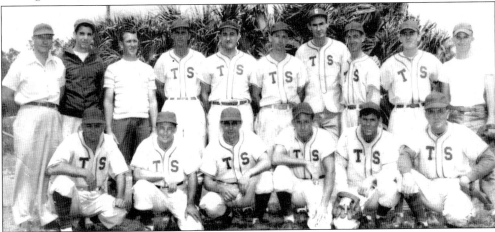

The Tarpon Springs Atlantic Ice Company Semi-Pro Team of the 1940s is pictured here. James Jenkins—a Palm Harbor native and a team member, who also played for the nationally-acclaimed Clearwater Bombers softball team—identified each of these players as follows, from left to right: (front row) the coach; Wes Henry of Crystal Beach; Vern Merritt; Jim Forehand; Charlie Barnes; and unidentified; (back row) Howard Gutherie, sponsor; Marvin Moore; Bobby Smith; Quinn Forehand; Jim Sakoitis; Richard Sutton, Jim Jenkins, Gene Walters, and Gene Hutto—all from Palm Harbor; and Doug Mason.

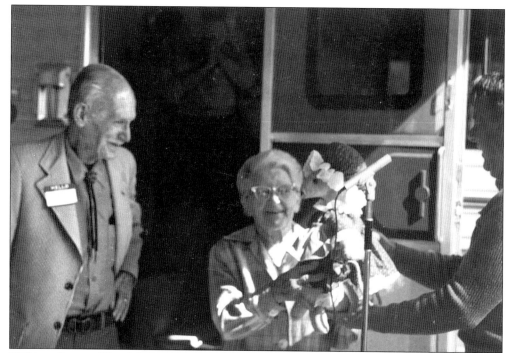

William Duane Wood Sr., whose family lived in Ozona for many years, and Mrs. Sarah Thompson Mann, a descendant of the earliest Thompson family, are recognized and presented special recognition at the first "Old Timer's Picnic" held at "Pop" Stansell Park.

From left to right are Mrs. Alice Craver Doud, Mrs. Edell Hogue, Mrs. Sara Thompson Mann, Henry Tinny, Dewey Adair, and Mrs. Alice Hill Noxtine, all descendants of pioneer families, being recognized and introduced at the first Arts and Crafts Festival—held by the chamber of commerce in downtown Palm Harbor every December for over 25 years.

Seven
THE HERITAGE
CONTINUES

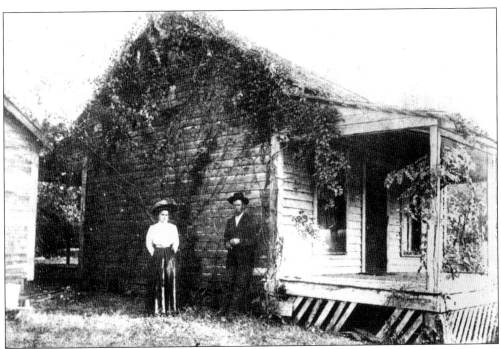

This 1916 photo of J.C. Craver and his niece, Florie Craver, is the only known one of him. It was taken at his home at that time, located at the northeast corner of Michigan Avenue and 12th Street in Sutherland. On this particular day, judging by their dress, one can assume that they were either ready for church or were going to a special event.

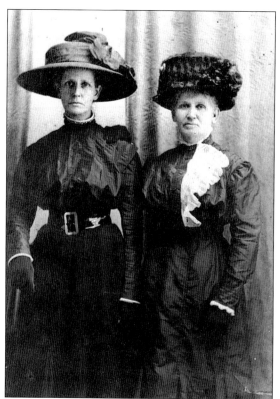

This photo, which was made into a postcard in the late 1800s, is an excellent representation of how the ladies of this area dressed for church or special occasions. The woman on the left is "Med" Holland, who owned the home that has become Molly Goodheads restaurant and bar in Ozona. The woman on the right is Sarah Holland, who was Ila Kersey McEachern's grandmother.

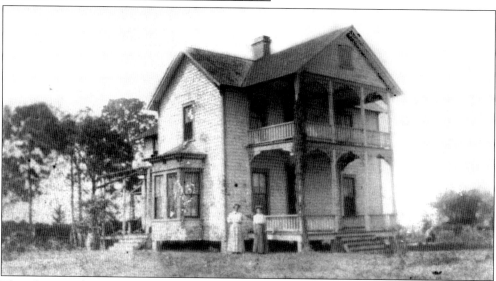

This photograph of an early Ozona home was donated to the local museum. A notice written on the photograph states: "Home I bought at Ozona. Edith and I (standing) by the house, ——, Mrs. Barco." An additional notice attached reads: "House bought by Mrs. Lucy (——), Aunt Lucy at Ozona." The structure of the home, with wide porches on the front and side as well as the alcove on the side, has features that were usually included in all Florida homes of that time. These provided shade for the main house and allowed the sea breeze to permeate the entire home. The house is built off the ground to allow for air flow.

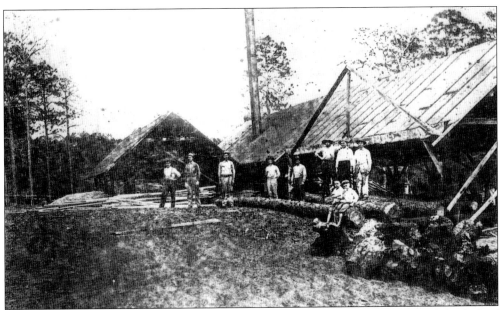

This was one of many sawmills that were in operation around Palm Harbor, until the lack of trees and housing growth brought about their demise. Pictured here is the Charles E. Jackson Sr. Sawmill, which was located in today's East Lake between 1912 and 1919. Jackson Sr. is standing in the middle of the three people on the log. The young boys seated are Alan Mann and Charlie Jackson Jr. Other figures in the photo include Hugh Hatch, Lewis Pickerd, Will Hayes, Charlie Green, and Henry Franklin.

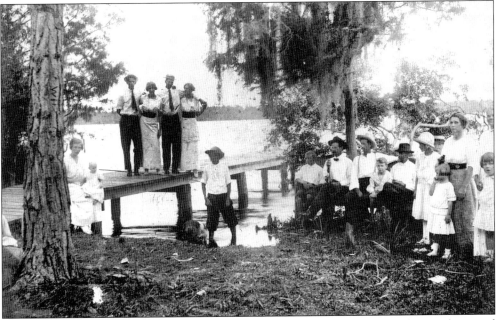

The Meyer family enjoys a Sunday picnic at their dock on Lake Butler (Tarpon) around 1915–1916. Perhaps this was a special birthday, anniversary, or such; however, a gathering like this never required a special occasion to be organized. From the dress and the history related to the author, this was most likely a significant occasion.

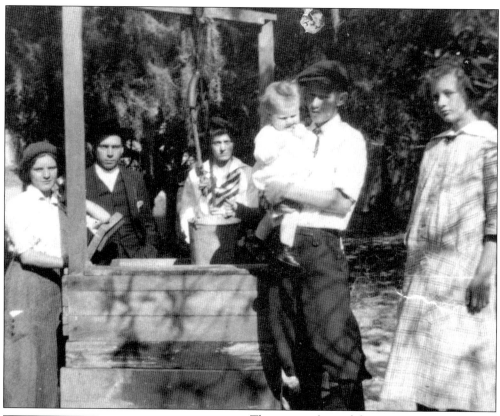

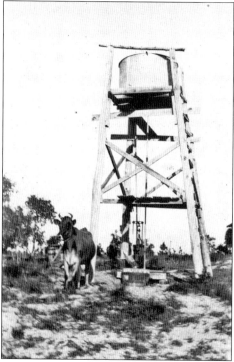

Thirsty members of the Meyer family attending the same picnic gather at the water well. They are, from left to right, Mattie, Ray, Hildreth, Roddie (holding baby), and Blanche Meyer. The well in this photo is exactly like ones that would have been found on every farm or country home at that time. Notice the bucket is set upright on the side of the well, with the rope and pulley used to draw the water from the well.

Daisy, the lone cow, refused to stay with the herd, preferring to stay close to the farm water tank. Someone snapped this photo to document her stubbornness. This particular water tank, located either on the Riviere or Johnson dairy farm, was used primarily for the cattle, including the mules and horses. Since there is no windmill, there had to be some type of motorized pump; this would have to be started on a regular basis to keep water supplied for the animals.

The Ozona Methodist Church, along with the parsonage and two other homes, was destroyed by fire in 1933. Very few people who now live in Ozona are even aware of its existence. Enid Fulford Fishman recalls both its existence and demise. This may be the only photo of that early building.

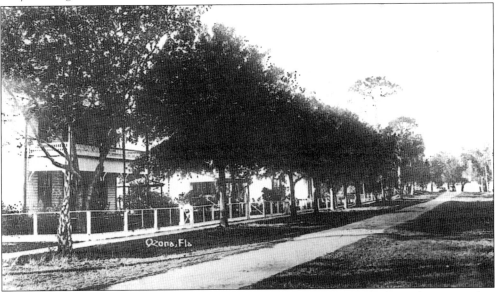

This scene of the west side of Bay Street in Ozona in the early 1900s looks to the west and to the bay. Four of the houses along here burned in 1933, including the Methodist Church (not shown) and, from left to right, the Methodist "Parsonage"; the original Whitehurst home, which was then owned by Miss May Lawler; and a two-story house owned by the Hendry family, which is where they finally stopped the fire. Enid Fulford shared so many of her remembrances, including these, of her beloved Ozona before her recent death.

At the Will and Ada Mae Dixon home in the 1920s, youngest son, Charles, feeds his pet hog in the recently harvested cornfield. The home was located approximately three-quarters of a mile east of today's East Lake Road; on their acreage, they raised their own vegetables, milk and beef cows, and hogs. Will Dixon's parents, the Aaron Dixon family, also owned several acres on the west side of East Lake Road and just south of East Lake High School.

Ella Amanda Dixon and her brother, Charles, enjoy a family outing by early East Lake Road. The fence in this photo was somewhat unusual in that day because a fence law was not yet in existence. The fence was put up to show ownership by a landowner, as well as to protect the gardens and lawn from the freely roaming cattle. There was also a cattle guard between the two large posts, which was created by digging a shallow ditch and placing small tree trunks lengthwise between the two posts. Later, round metal pipes were used. Since the picture was taken c. 1930 when the Depression was in full swing, these were most likely tree trunks.

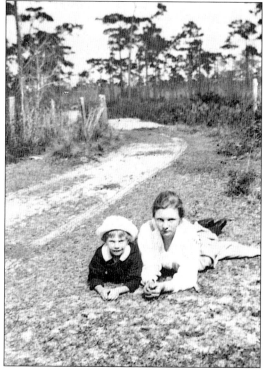

The cost of the funeral of Stephan Willard Dixon (or Will, as he was known to all locals) is shown here in his son-in-law's records. Will thought he had developed a cancer from a thorn that had become imbedded in his neck from picking fruit. Whatever the cause, over many years he continued to become more incapacitated, and he finally died at an early age as a result of that illness.

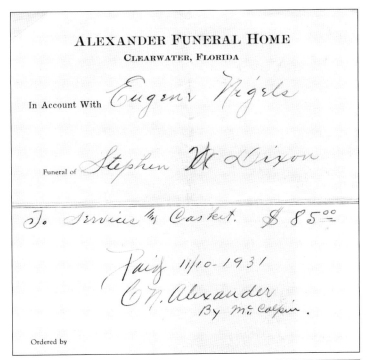

ALEXANDER FUNERAL HOME
CLEARWATER, FLORIDA

In Account With *Eugene Nigels*

Funeral of *Stephen W. Dixon*

To Services and Casket. $ 85⁰⁰

Paid 11/10-1931
C. N. Alexander
By Mc Calpin.

Ordered by

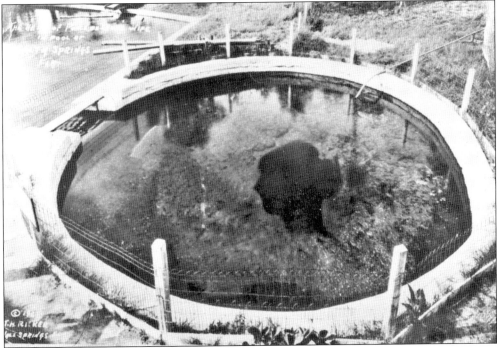

This postcard is dated 1917, the time when Wall Springs was just becoming known as a healthful swimming area. There is only a wire fence and posts around the spring itself. The natural formation of the spring has produced the shape of a woman's head, which is clearly visible in this photo. The story is that this is the head of Ponce de Leon's wife, and he saw it on his journey through the area.

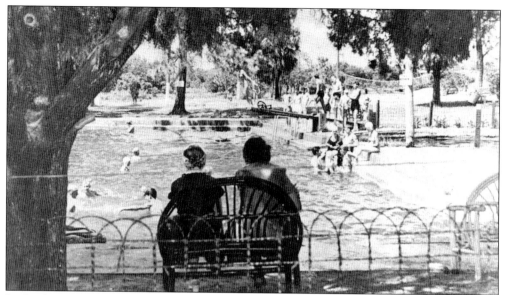

In this later photo of Wall Springs, a waterfall can be seen at the north end of the pool; a diving board has been added at the spring (east) side of the pool. The volleyball nets are ready for play, and the picnic tables are placed well away from the pool area. A fence remains around the actual spring, as does an enclosure for the general public. People could sit outside the enclosure for little or no fee. However, to go down to the pool area, as these ladies have done, a patron was charged the full price.

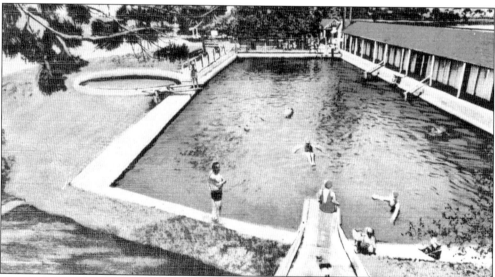

This 1926 postcard gives a better view of the entire pool area. The information on the card tells us that this is the "Health Springs Lithia Swimming Pool at Wall Springs, Florida," located "3 miles south of Tarpon Springs and 10 miles north of Clearwater." Although the diving board is still in place, the fence around the pool is gone, and a slide had been added at the deeper end. Also, the drain pipe in the very low center of the bathhouse area can be seen. As someone who frequented this pool, the author can recall the times boys would swim through the pipe to the open bay waters in the west. The girls always admired the boys who did so, discounting any danger, which (fortunately) never occurred.

110

This unidentified young lady went to Wall Springs for a relaxing outing on a weekday, during which the members of this family were the only other ones there. The young people loved to try to stand and roll these large logs that were either in the pool or could be placed in the water, much as we now know is done with timber in the northwest and other areas. In the early 1940s, such adventures were unheard of, so people just enjoyed the thrill of trying to stay on the log yet loved it when they fell.

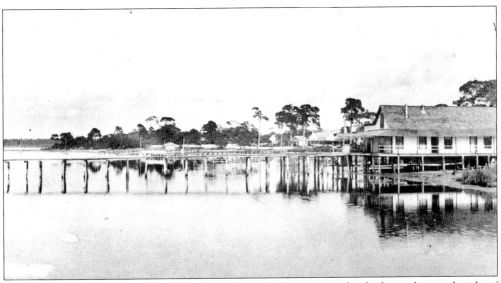

L.H. Eavey's mercantile business was located at the beginning of a dock on the north side of Bay Street in Ozona. Apparently, Eavey had almost any staple merchandise his customers would want. The water was usually very shallow; therefore, the larger ships would anchor offshore and bring the merchandise to the store in dinghies. The freeze of 1886, in effect, put him out of business. In 1889, the doctors H.K. and Susan Whitford took over the building for their practice.

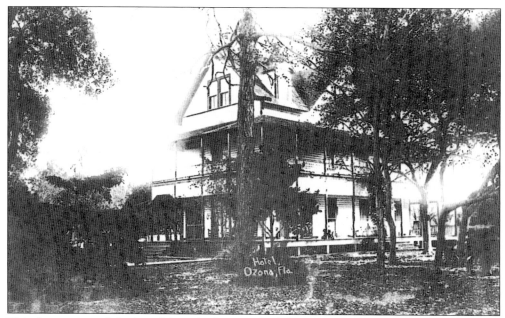

This first section of the later Magnolia Inn was built by Eavey for his bride, Miss Ebie Tinny. Originally, it was a one-story home with four large bedrooms. They were soon asked to take in boarders. With the arrival of the railroad and, consequently, more people stopping in the area, the home was greatly enlarged to accommodate those wishing to stay for a while. This photo shows those early additions of nine bedrooms, a large kitchen, and dining room in 1893.

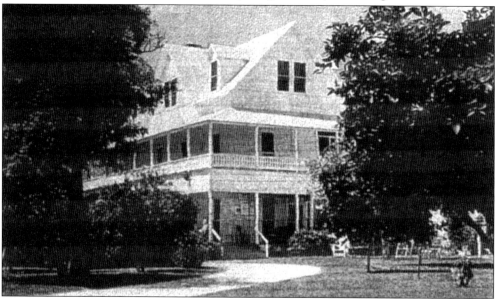

In 1905, Mr. Eavey leased the inn (as seen above) to two maiden friends. They continued to operate it for about 15 years, after which time it had several owners; it was sold to Mrs. Alice Roach in 1940. She operated it for 30 years when, because of extensive new code requirements, it was demolished, and modern apartments were built in 1975. Through all those years it became *the* place to go for Sunday dinner. It was not unusual for people to take the train from St. Petersburg or Tampa just for that meal.

The beginning of the Magnolia Inn dock can be faintly seen to the center right of this 1942 photo of Bayshore Drive looking south to Bay Street in Ozona. This was a nice wide dock that the inn patrons loved to use for fishing or watching the beautiful Florida sunsets. Part of a postcard that was written about this location says, "I think this is one of the prettiest bay fronts in Ozona." This portion of the road is now closed to traffic.

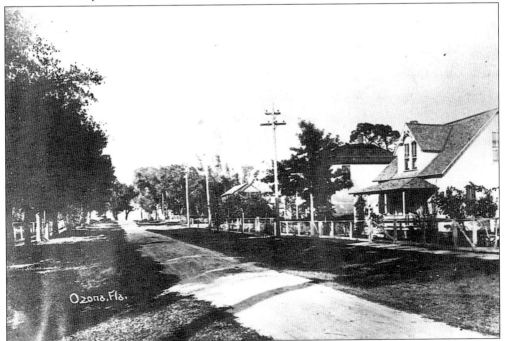

This view of the north side of Bay Street is looking west. Some of the buildings in the photo are still standing and occupied today. Others have either burned or been torn down, with newer homes erected in their place. Dr. Grace Whitford lived at the far west end of the street.

This was one of the parks that used to be located in Ozona. Another quiet place to sit, rest, or read, it was also good to just watch the fish jump or see someone catching mullet for dinner that evening. Now, homes cover nearly the whole property; nonetheless, this particular part of Ozona is still very much as it was in the 1940s when this photo was taken.

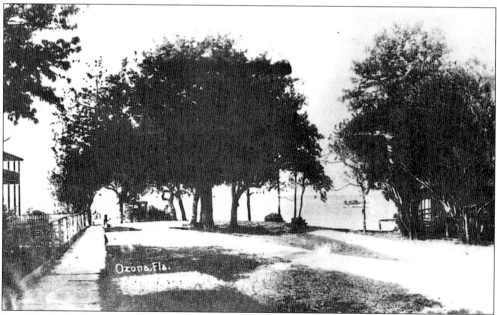

Dr. Whitford's home, on the right, is located at the end of Bay Street in Ozona in 1942. Bayshore Drive can be seen turning left at the end of Bay. The sidewalk was built in the early 1900s by the Ladies Improvement Society, the forerunner of today's OVIS (Ozona Village Improvement Society).

Ozona Townsend Club
Ozona Fla. 6/19/39

Club was called to order by
Chairman. After opening as
prescribed, and reading minutes
the meeting was turned over
to our good friend (a "good
Townsendite) Mrs. Block of
Tarpon Springs, for her much
appreciated and very impress-
ive Townsend dialogue.
Next on the program was
our Townsend Musician
Rheba Ulmer. Rheba was
as usual, both good and
appreciated.
Monthly dues then were paid
to the amt. of $1.55.
Meeting adjourned until July
17th.

W. P. Sutton
sec.

Townsend Club meetings, minutes from which are seen here, were held in Ozona for the entire area on a regular basis. This organization has often been credited with being the beginning of what is known today as Social Security. Enid Fishman has written that she remembers "attending their meetings with her mother, Eula Fulford, and some of her elderly neighbors when she was a teenager. A number of Ozona Senior Citizens were enthusiastic about this plan which predates Social Security." This particular meeting was held on June 19, 1939, at the Ozona Recreation Club building. Rheba Ulmer (Sutton) is mentioned as the "Townsend Musician,—was as usual, both good and appreciated." Monthly dues are listed as $1.55 a month, which would have been somewhat high for many of the workers of that day. The author well remembers hearing about the Townsendites from casual conversations; although the author's parents may have been members, this was one aspect of life that was not shared. The secretary was W.P. Sutton, a highly respected member of the community, as well as a member of the Sutton family of settlers.

Rheba Ulmer Sutton (right), known throughout her life for her ability on the accordion, played for events such as the Townsend Club meetings. Here she is with her very good friend, Peggy Erickson.

For several years, this group would gather for an evening of playing their favorite instruments and talking. As friends learned of their hobby, they were asked to play for various organizations of the area; this photo was taken at one such event. Calling themselves the Pinellas Pioneers are, left to right, Eddie Sutton, guitar; his father, Wallace Sutton, mandolin; Marty Moreland, guitar; Marty's mother-in-law, Rheba Sutton, accordion; Charley Jones, guitar and vocals; and Eddie Vought, harmonica and organ.

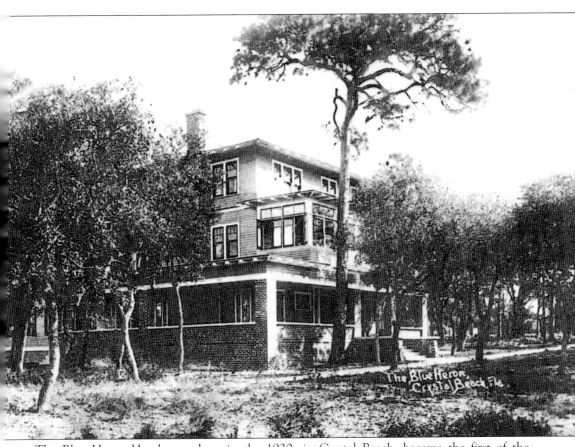

The Blue Heron Hotel, seen here in the 1920s in Crystal Beach, became the first of the buildings that comprised the Faith Mission in 1929. The Reverend Fred Markert (1875–1948) and his wife, Cora A. Markert (1874–1939), had volunteered as missionaries to the Canary Islands. They realized, however, that their language skills prevented them from being as effective as they believed they should be. The Markerts returned to the Tampa Bay area, where, in 1929, they recognized the obvious needs of orphaned or unwanted children and contemplated how they could help them. In a very short time, they were told of a tourist hotel in Crystal Beach, which—due to the Depression years—could be purchased. They proceeded to do this with help from anyone willing to aid them. Thus, the Blue Heron Hotel became the first building of the Faith Mission. This effort was a work of faith: non-sectarian, they made no solicitations and had no sponsors, yet it became known nationwide for the gentle and loving care that up to 100 children at a time received. When some of the children (who are now in their later years) have spoken about it, even they remain amazed at how, when money was scarce, someone would appear with just what was needed. These adults have told of the care and love they received, along with the discipline that children require. All have been delighted to talk about their experiences and how they learned from that early time ways to deal with any adversity in their later lives.

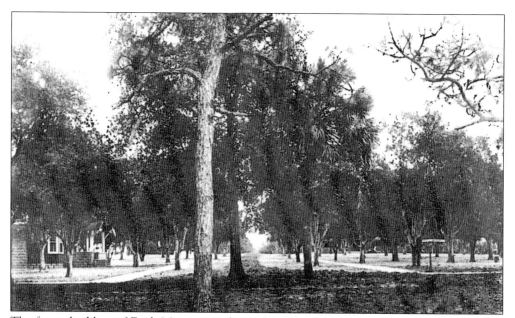

The future building of Faith Mission was located on this park property in Crystal Beach. The children of the Faith Mission frequently put on musicals and other shows. Rheba Sutton reported: "I used to go on Sunday afternoon to hear the children play music. I became acquainted with some of the students."

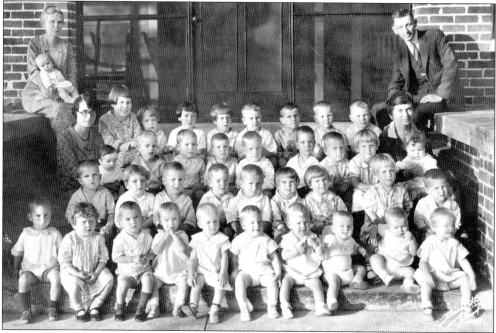

Reverend and Mrs. Markert sit on the walls of the steps in this photo from the 1930s with one of their preschool classes. Two unidentified adults, presumed to be the teachers, also sit with the children. Through all the years of the Faith Mission's existence, the children were regularly enrolled in the public schools; they were accepted and treated the same as all other local children.

A copy of the original deed for Indian Bluff Island, then comprising
21.83 acres. It was homesteaded by Mr Robert E. Gause for seven years,
1914 to 1921, and conveyed to him by this deed for $27.29 ($1.25 per
acre). This copy was given to Ray S. Leach for I B I C A by
Mr Roy C. Gause (Son of Robert) on May 15, 1974.

4—1020.

Gainesville 015993.

The United States of America,

To all to whom these presents shall come, Greeting:

WHEREAS, a Certificate of the Register of the Land Office at Gainesville, Florida,

has been deposited in the General Land Office, whereby it appears that full payment has been made by the claimant

Robert E. Gause

according to the provisions of the Act of Congress of April 24, 1820, entitled "An Act making further provision for the

sale of the Public Lands," and the acts supplemental thereto, for the Lot three of Section twenty-

six, the Lot one of Section twenty-seven, the Lot two of Section thirty-

four and the Lot two of Section thirty-five in Township twenty-seven

south of Range fifteen east of the Tallahassee Meridian, Florida, contain-

ing twenty-one and eighty-three-hundredths acres,

according to the Official Plat of the Survey of the said Land, returned to the GENERAL LAND OFFICE by the Surveyor-General:

NOW KNOW YE, That the UNITED STATES OF AMERICA, in consideration of the premises, and in conformity with the several Acts of
Congress in such case made and provided, HAS GIVEN AND GRANTED, and by these presents DOES GIVE AND GRANT, unto the said
claimant and to the heirs of the said claimant the Tract above described; TO HAVE AND TO HOLD the same, together with all the
rights, privileges, immunities, and appurtenances, of whatsoever nature, thereunto belonging, unto the said claimant and to the heirs and
assigns of the said claimant forever.

IN TESTIMONY WHEREOF, I, Warren G. Harding,

President of the United States of America, have caused these letters to be made

Patent, and the Seal of the General Land Office to be hereunto affixed.

GIVEN under my hand, in the District of Columbia, the THIRTIETH

day of APRIL In the year of our Lord one thousand

nine hundred and TWENTY-ONE and of the Independence of the

United States the one hundred and FORTY-FIFTH.

By the President: Warren G. Harding

By M. P. LeRoy Secretary,

S. C. Lamar,
Recorder of the General Land Office.

RECORDED: Patent Number 804986

Indian Bluff Island was originally a separate island in the Crystal Beach/Wall Springs area. As
this copy of an original deed reveals, Robert Gause homesteaded it in 1914. For 21.83 acres he
paid, by his homestead rights, a total of $27.29—or $1.25 per acre—for the entire island.

119

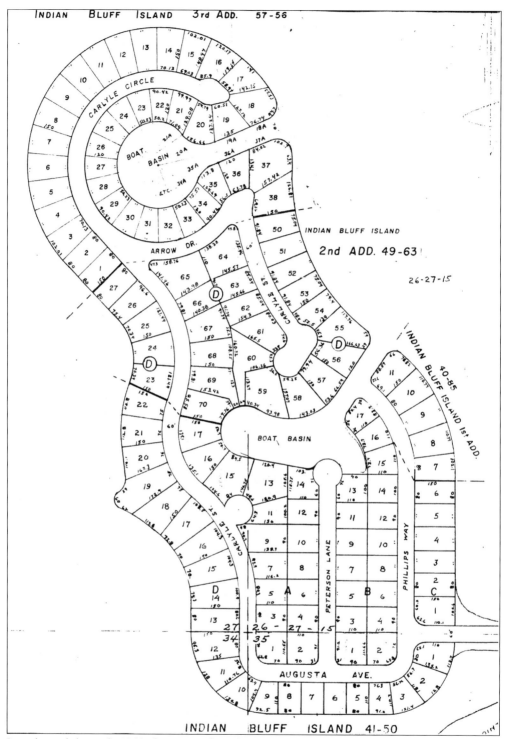

It took until the early 1960s for any modern development to happen on Indian Bluff Island. The developer's design shows the numerous individual lots that would be available, as well as plans for those who wanted to have boat access to the open water.

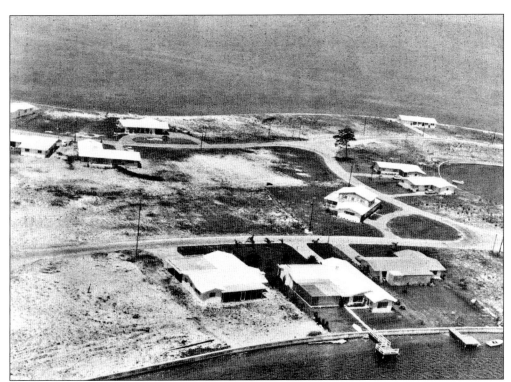

This aerial view of Indian Bluff shows development beginning. People were particular as to which lot they wanted to buy; some wanted to be waterfront, while others chose to be more landlocked but would have still been able to take advantage of the Gulf breeze. Of course, a road was required to be filled and built from the mainland to the island.

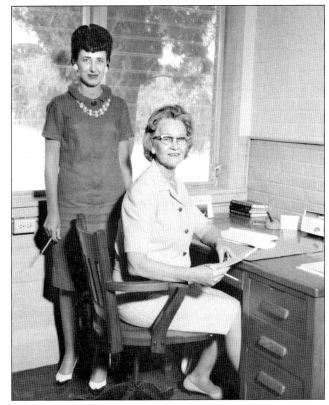

Even before Daisy Riviere (here seated at her principal's desk at the Ozona Elementary School) had retired, she bought a home on Indian Bluff Island. She always said that her paternal family had been close to the sea and that she also wanted to be so situated. Her secretary of many years, Helen Berry Tinney (Kamp), is also shown.

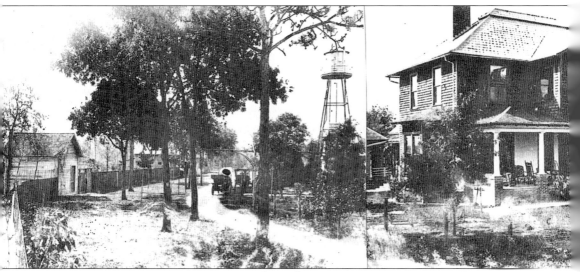

The Wall Home and grove was located on the east side of Alt. 19 in Wall Springs. This panoramic view shows the drive around the house, along with a fence surrounding the home and yard area to keep the cattle from this property. The unofficial information is that Mr. Wall,

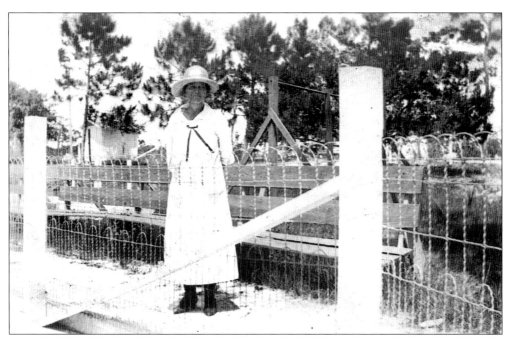

Mrs. J.L. Beckton, whose home and family farm was a fairly short distance away, also took time from her home duties to relax at Wall Springs.

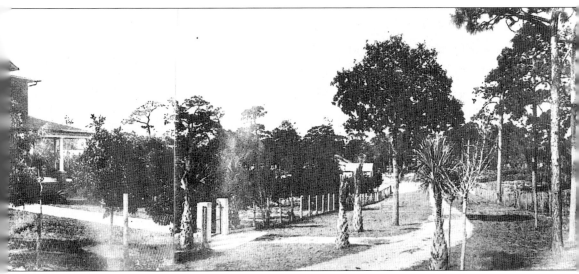

who was a partner in a large business in Tampa, had a daughter with health problems. Therefore, he had this house built so that his daughter could take advantage of Wall Springs, which was also owned (and so named) by him.

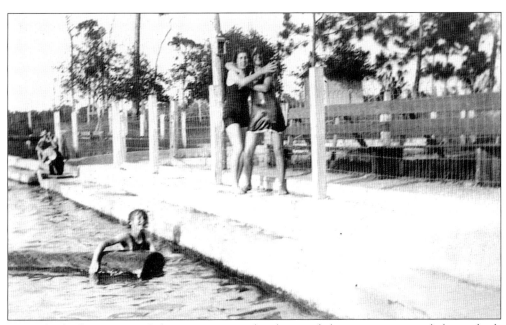

From the bathing wear of the participants, the donor of these two pictures believes both photographs were taken the same day in the 1920s. These may be the Beckton children with some of their friends.

CAMP FIRE GIRLS

OSCEOLA

OZONA FLORIDA

THIS IS YOUR CHARTER. MAKE IT LIVE,
AND FIND HERE, HIDDEN WITHIN ITS PAGE,
THE DEEPER MEANING —
THE RIGHT TO JOIN THE CIRCLE'S SISTERHOOD
YOUR HEARTS TO BEAT IN TOUCH AND TUNE WITH THEIRS;
THE RIGHT TO KINDLE AT THEIR FLAMING FIRE
YOUR OWN, AND SEE WITHIN ITS GLOW
THE SPIRIT-FLAME OF WORK, LOVE-ORDERED;
TO FEEL STRONG PULSING THROUGH
EACH DAY AND YEAR
THE SWEET, FULL SURGE OF GLOWING HEALTH;
THE RIGHT TO LIVE THE EXULTANT LIFE
THAT GROWS AKIN TO NATURE'S THROBBING HEART;
THE RIGHT TO DREAM, AND DREAMING,
KNOW THE DEEP PRIMAL THINGS,
THE SOUL OF BEAUTY AND THE HEART OF TRUTH;
ALL THESE ARE YOURS, ·
YET ONLY IF YOU TAKE AND MAKE THEM SO.

Acting PRESIDENT SECRETARY

AUGUST 1919 No 19249

The Camp Fire Girls Charter was a highlight for many of the young ladies of the area. Until that time, there had been little organized activities for girls, except for a specific church-related one. Many of the girls of that day, including Enid Fulford Fishman and Fay Allison, recall their activities, including campouts, socials, and other learning experiences. The former 4-H Clubs (now non-existent in this area) and, more recently, the Girl Scouts have replaced the particular fellowship that was developed in such organizations.

Rebecca Sutton (Moreland) models for a 4-H Club and Channel 10 television show. Television was a fairly new experience at the time, a few years beyond the scope of this book. However, it had (and continues to have) such a strong influence on our lives, it seems appropriate to mention its early beginning. This young lady, the daughter of Richard and Rheba Sutton, continues to inhabit—and contribute positively to—our community.

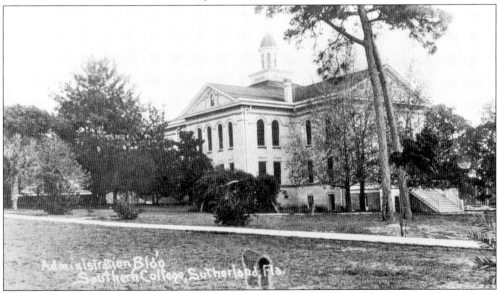

Here is a somewhat different view of the Administration Building of Southern College when it was located in Sutherland, revealing the truly imposing size of the building. This photo is from the east side; therefore, the Tea House would have been on the immediate lower left of this building, with the parade grounds where the photographer was standing.

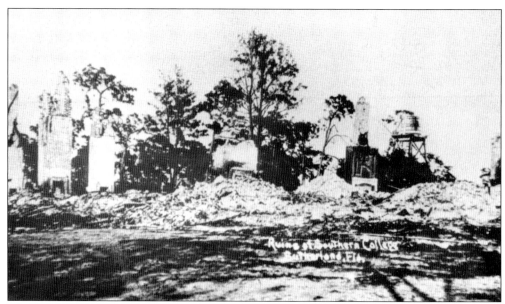

The few remains of the San Marino Hotel/ladies' dorm and the Administration Building clearly reveal the total devastation of those two buildings. Alfred Boyd recalled that flames could be clearly seen from his family's home on Main Street in Dunedin. Charles L. Jones, who lived on Nebraska Avenue in Sutherland, also recalled hearing the roar of the fire and the flames. He went to the scene, only to see that neither the Tarpon Springs nor Dunedin fire trucks could even approach the fire. Not even the water tank could benefit the firefighters.

In 1958, the citizens of the unincorporated communities of Ozona, Palm Harbor, and Crystal Beach decided that enough buildings—and finally, a life—had been lost to warrant following through with long-discussed plans for a community fire department. This group of volunteers, along with others, began with equipment from the various area groves. A signal was arranged, according to location of the fire, and volunteers responded accordingly. This photo is before the first station, centrally located at Illinois Avenue and 11th Street in Palm Harbor, was built. The fire vehicles were serviced at the Stansell Garage, just west of that planned building, where this photo was taken.

A few years later, this groundbreaking was for the third fire station, Innisbrook, in the O.P.C. (Ozona, Palm Harbor, Crystal Beach) officially state-approved fire district. The district had been drawn and approved by the Florida Legislature under the leadership of the state senator at the time, Curt Kiser. It also created a special taxing district for the fire department, as well as for a public library and a recreational district. The East Lake area had been encouraged to join in the district but chose not to do so.

The first real fire truck for the O.P.C. Department was donated to the Palm Harbor Historical Society by the (then) tax-supported department. Although the name was changed to the Palm Harbor Fire District—to the dismay of many early Ozona and Crystal Beach fire volunteers— the Fire Board agreed that this truck, which had outlived its service as a regular firefighting truck, could continue to serve both the fire department and the historical society. Thus, it is regularly seen driven by certified volunteers in state-wide parades and local events, as well as during the December holiday season when the area is covered with scheduled holiday trips.

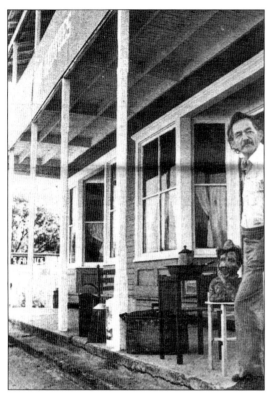

Bill Hoskins was one of the major instigators for today's Chamber of Commerce Arts and Crafts show, held every December. Bill, although not a native, loved this area as much as anyone and was always looking for ways to promote its business and preservation. As an artist himself, he came up with the idea, which was recognized by many as a unique opportunity to share the local history and culture. He is shown standing on the porch of the historic Hill Building in Palm Harbor's historic district.

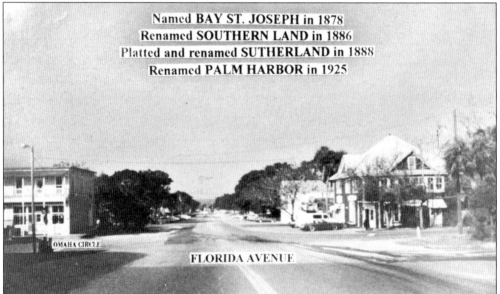

Named **BAY ST. JOSEPH** in 1878
Renamed **SOUTHERN LAND** in 1886
Platted and renamed **SUTHERLAND** in 1888
Renamed **PALM HARBOR** in 1925

OMAHA CIRCLE

FLORIDA AVENUE

A fairly recent (1970s) photo shows most of the now-historical district of Palm Harbor, which the Palm Harbor Historical Society was instrumental in creating in 1994. This photo was taken from the intersection of Omaha Street and Florida Avenue. This 110-foot wide street, as originally plotted, continues to captivate visitors and old timers alike with its wide-open view of the bay and gulf. It makes it understandable why so many people chose to make this entire unincorporated area their new home.